ANNIE RATTI

CHARTA

CONTENTS

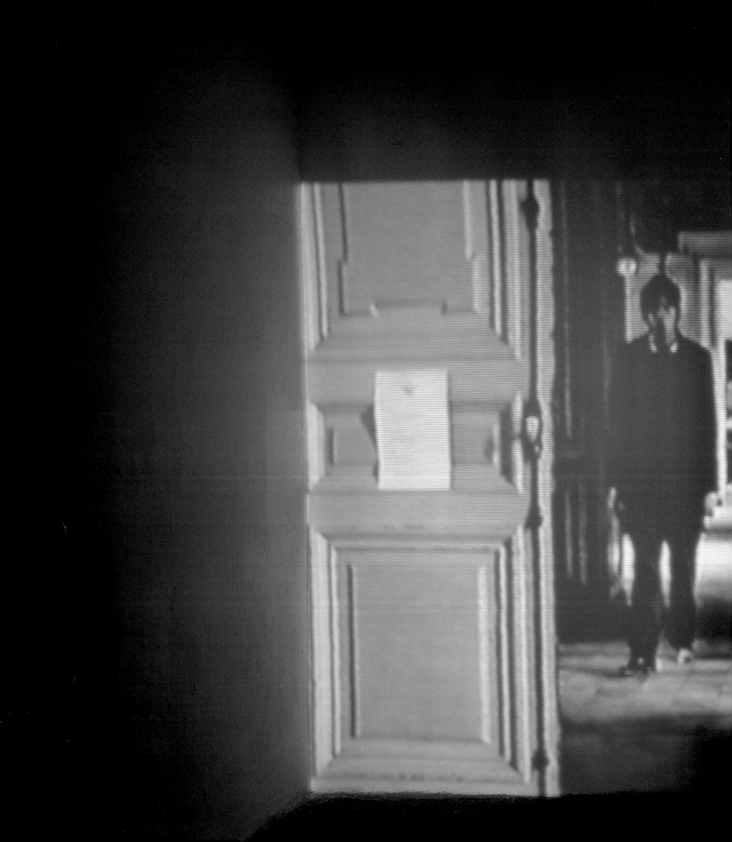

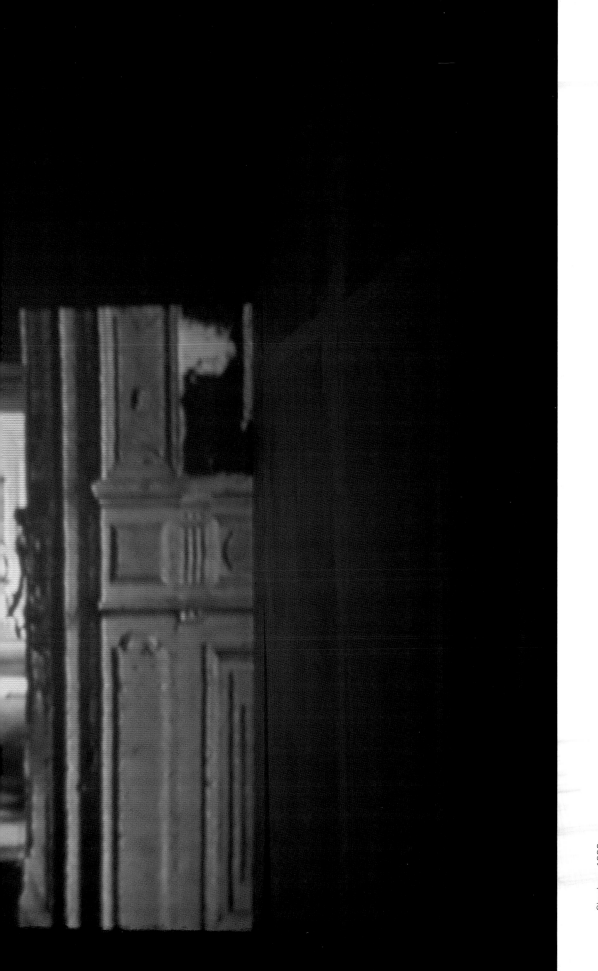

Shadow, 1996
video projection, b/w, 4 min.
200x250 cm

Urban Castaway

by Iwona Blazwick

*The artist and the tramp have something in common...**

An elegant, ornately paneled room opens out onto a perfect replica of itself. The second room is a mirror reflection, but there is an added presence. A barely discernible figure stands inside the reflection, a shadow that has no origin. This phantasm stands as if to momentarily orient itself within this space before moving on. Titled *Shadow*, this haunting evocation is a work created by Annie Ratti for a solo show at l'Espace d'Art Contemporain in Paris in 1996. The figure is in part a memory, a schizophrenic patient in "La Borde" at the Felix Guattari Psychiatric Clinic, walking up and down, with the gait peculiar to those with autism. At the same time it is a ghostly wanderer, a kind of itinerant presence that floats through much of her work.

Perhaps the wanderer is also the artist herself. Ratti was born in Switzerland and brought up in northern Italy. She studied in Paris and New York and has pursued a peripatetic existence living and exhibiting around the world. Like many artists of her generation, her practice is relativist and site-specific.

Ratti creates images, objects, and environments that offer some reflection of the site in which she finds herself. She also uses objects and materials to communicate a subjective experience of that place. At the same time, she creates spaces that offer a kind of suspension that is analogous to the concept of the non-space, or utopia. Her work operates, therefore, on both an existential and social level.

The leitmotif that runs throughout her work is that of voyages and arrivals—not as a narrative device, as in literature, but rather in spatial terms. In 1996, she transformed a room in the Heiligenkreuzerhof, Vienna, into the surface of the city at night. The room was lined with a thick black textile, absorbing all light and sound. Punctuating this material were thousands of tiny fiber optic lights tracing concentrations of buildings and roads. This

Vuoti d'acqua (Water Voids), 1999
light-box
128x176x15 cm

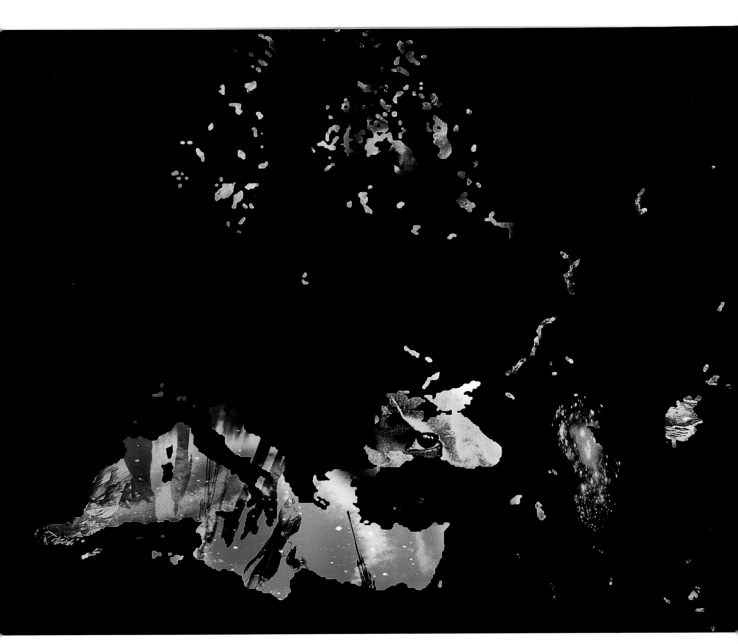

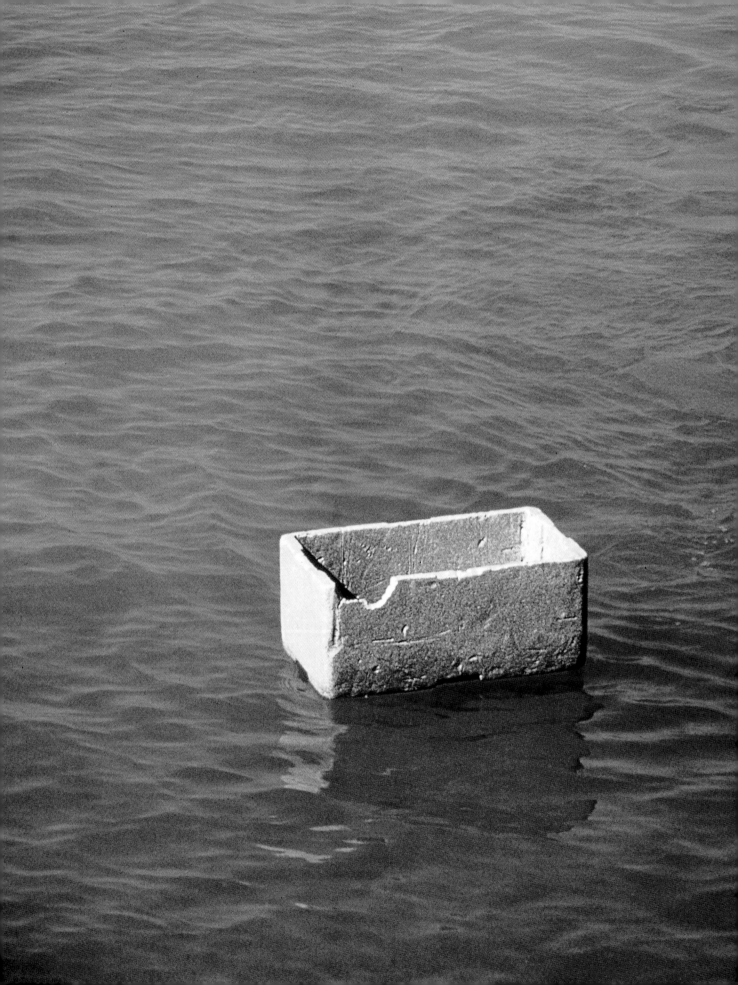

view of a conurbation abstracted into a sparkling mosaic of spangled light is only available to the airline passenger, to the detached, disembodied traveler whose feet do not touch the ground. Ratti transports us further by rotating this essentially aerial perspective so that it is viewed not below our feet, but on the ceiling. We are invited to lie back and see the world hover above us, twinkling, out of reach, enticing yet unknowable.

To travel is to depart from the patterns of day to day existence, to step out of the role of protagonist into that of observer, temporarily surrendering agency to external forces and unpredictable encounters. This state of suspension is powerfully expressed in the recurrence of bodies of water throughout Ratti's oeuvre. An emphasis on the matter of the natural world, its force fields and temporal zones is a legacy of the Arte Povera and land art movements. However, Ratti also imbues her use of water with a psychological and even political meaning.

Vuoti d'acqua (1994) takes the form of an advertising light-box. A feature of every street and airport, this is the pictorial space *par excellence* of the itinerant spectator. Again, Ratti offers a kind of negative map, this time of Europe. Its landmass is a black void punctuated by all the landlocked bodies of water around the Mediterranean, illuminated in vivid color. These "voids" are filled with images picturing political events—and the sky at night. The conflict and turmoil of society is juxtaposed with the sublimely indifferent cosmos, which in its enormity reduces whole eras of political unrest into mere flickers in an eternal night. The miniaturization and abstraction of a map, in itself the emblem of the traveler, also reinforces an ongoing preoccupation with travel and disconnection.

An evocation of voyaging is reiterated in another illuminated photograph featuring a white rectangular box, one edge of which is damaged, floating at sea. This crude "boat" looks as if it is cast from clay like a hollow brick. It may be a vessel or a piece of debris after a flood. We cannot see inside to discover whether there is a passenger or a message. *Apparizione* is an image of dislocation, of temporary suspension. Neither coming nor going, the object is rudderless and at the mercy of the forces around it. Part of an installation called *I Love You*, it takes on an existential quality where emotion is made analogous with being adrift at sea.

If the artist is a castaway, then she must have a raft. This is another trope within Ratti's oeuvre. Her sculptures have included a small space ship (*Soucoupe*, 1997), a vast inflatable dinghy (*Fin de siècle*, 1999), and a flying bed (*Letto volante*, 1997). This last work comprises a large trapezoid mass suspended from cables in mid-air. It looks soft and plush, but maintains a rigid form and has a bright blue waterproof PVC skin. A rope ladder hangs over one side. Ratti has metaphorically flooded the gallery and offered us a lifeboat. The pliant surface of this floating volume and the title of the work insist that this "vessel" is a bed. The artist has commented:

I made this piece for the Officina Italia exhibition at the Galleria d'Arte Moderna, Bologna, where the extreme height of the central room made it the ideal place to suspend this bed-navicula that could be reached by means of a small ladder. The desire for a flying bed stems from the world of fairytales and dreams of which I am still particularly fond. Sleep and travel are both instances of suspension, a way of being in no place: two 'little deaths' as Paul Virilio calls them.

It is a sculpture that invites us to dream. As with all of Ratti's objects, *Letto volante* is both functional and symbolic. To dislocate is also to enter the space of the imagination.

Complementing moments of suspension and detachment, Ratti offers resting places, temporary shelters, and oases of repose and reconnection. In her typical style, she fuses architecture and design in forms that curl around the spectator—take her furry *Biblioteca* (1997) with its two halves cupping and secluding the reader. Like artists such as Jean Marc Bustamante or Franz West, Ratti uses the vernacular of furniture and craft, offering objects that are useful and evocatively familiar. This fully functioning bookshelf is, however, padded with fake fur. The cases are also enclosures offering full immersion in the destabilizing force of the books she has arranged inside—many are radical essays, political treatises, psychoanalytical texts that have made the shelves themselves tilt. Ratti encloses viewers into the secure space of the domestic and then exposes them to new intellectual horizons.

In 2000, she was invited to make a project at the Kunsthaus in Bregenz, on Lake Constance. She presented a number of bird-

Soucoupe (Saucer), 1997
resin, wood, electrical lights, motor, radio control, polyurethane foam, musical accompaniment "La valse à Mille Temps" by Jacques Brel
60x ⌀160 cm

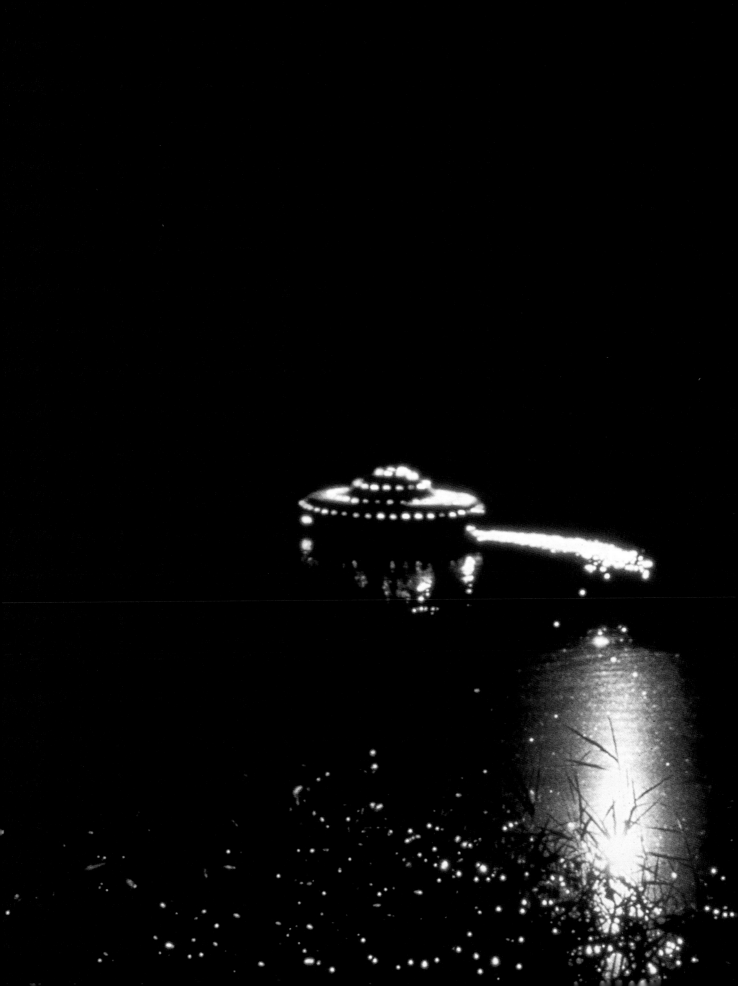

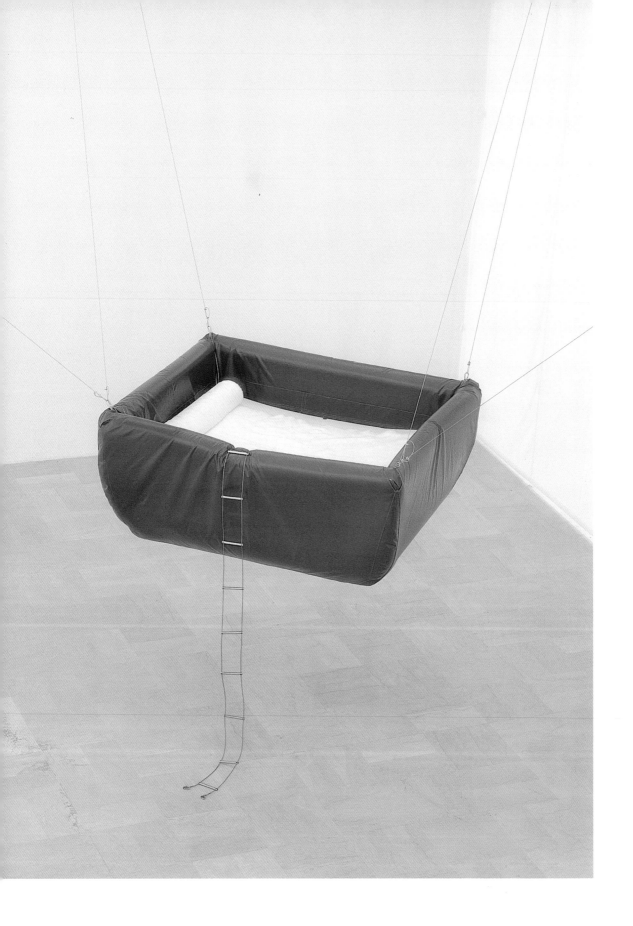

Letto volante (Flying Bed), 1997
PVC sheet, metal structure, foam rubber,
fabric, steel cables, technical ladder
80x180x140 cm

Fin de siècle (End of the Century), 1999
inkjet print on gauze, wooden frame, earth,
barley seeds, waterworks, PVC life belt
70x ø420 cm

15

houses, one of which floated on the lake. In her proposal for the project she states:

Lake Constance, in front of Bregenz, represents an important site for migratory birds, some of whom spend the summer there and leave for Africa in the winter (Mehlschwalbe, Mauersegler, Rauschwalbe, Star, Kuckuck, Bachstelze, Schafstelze, Rohrammer, Goldammer, Singdrossel, Gartenrotschwanz, Rotkehlchen, Schwartzkenlchen, Fitis, Kiebitz). Other birds live there all year round (Amsel, Drossel, Misterdrossel Kohlmeise, Blaumeise, Tannenmeise, Haubenmeise-Sperling, Buchfink, Grunling, Erlenzeisig, Stieglitz, Gimpel Zaunkonig, Specht, Eichelhaher, Elster, Dohle, Rabenkrane, Kolkrabe). The winter is cold and very long: it snows. The birds sometimes have a hard time finding food and protection from the intemperate weather. My project is to create a more welcoming, comfortable environment for the birds. I am creating a platform in the shape of the island of Madagascar where the birds can rest and create their own territory outside the water. I will install some birdhouses in the trees and some bird tables: a refuge for the birds in the park between the city and the lake.

Rather than create an image of a landscape, impose a structure on it, or intervene in its topography with a monolithic earth-work, Ratti makes a typically subtle and generous gesture with her beautifully made birdhouse and bird island. The natural world becomes again an analogy for a migratory existence— migratory rather than migrant. Ratti does not seek to represent the plight of the refugee. The birds are driven by atavistic forces over which they have no control. Ratti offers strategies for survival for those who share with her the impulse to roam.

Conceived to hang from a tree or a rafter, *Nido* (1999) comprises an enormous egg-like form hanging from a chain. Ratti has commented on this work:

I created this piece for a group exhibition in the home-studio of a fellow artist not far from Orvieto. The nest (nido), which was exhibited in the woodshed beside the house and suspended from a beam, once reconstructed looked as if it had grown on site like some outsize protuberance. Halfway between a spaceship and the closed round of a nest, access to the piece came in the form of a rudimentary ladder fashioned from steel cables. Once inside, visi-

Biblioteca (Library), 1997
plywood, varnish, padding, fake fur, books, objects, video tapes
four elements
220x ø350 cm

16

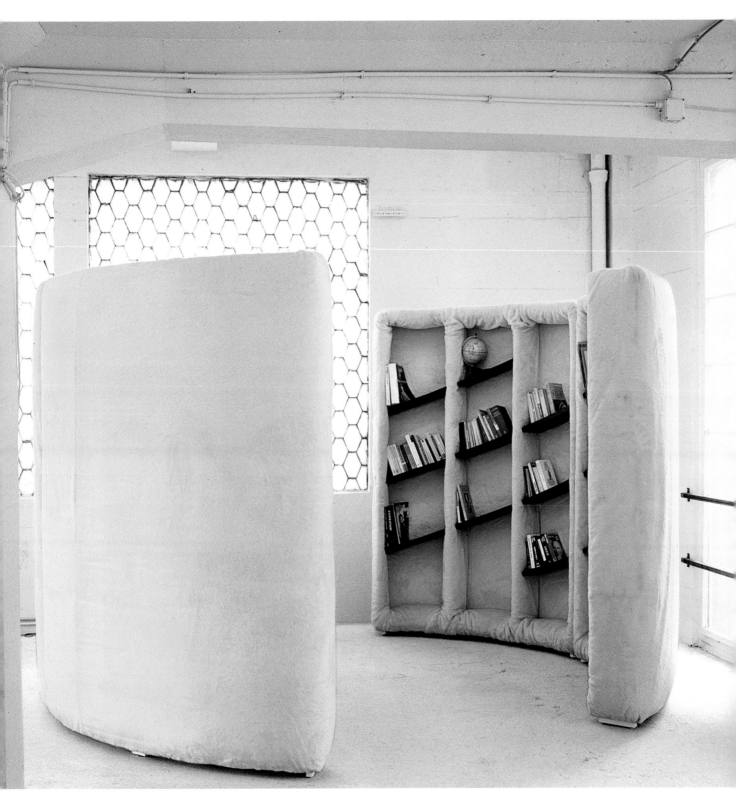

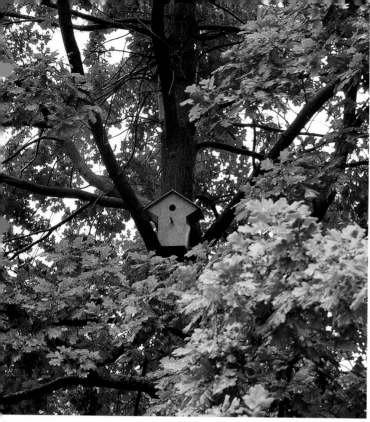

Bird's House, 2000
plywood
55x105x185 cm circa

Bird's Table, 2000
plywood
90x60x185 cm circa

18

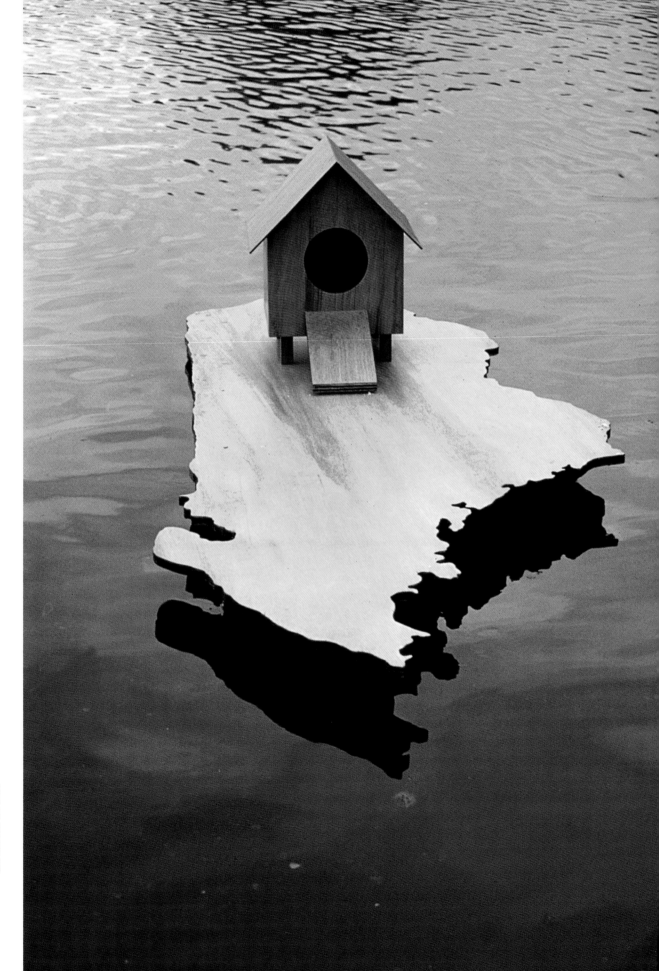

Bird's Island, 2000
plywood
55x105x185 cm circa

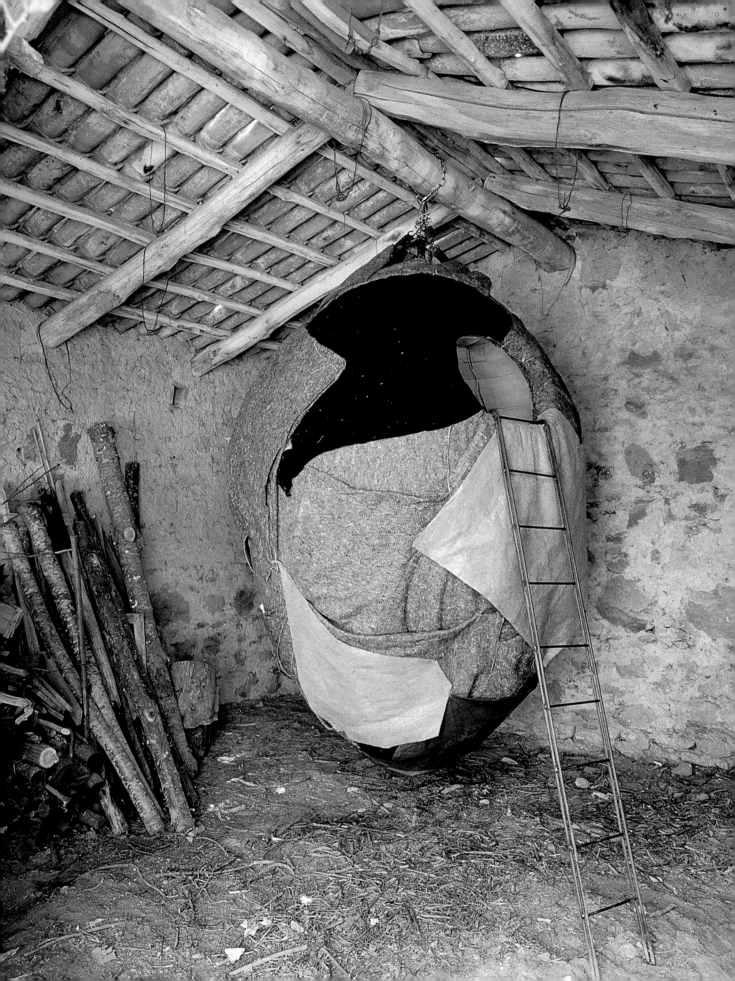

tors found a comfortable base of foam rubber, fabric mattresses, and sleeping bags. A relaxing soundtrack, created expressly for the setting, played inside.

The various component materials of the nest were intertwined in much the same way as a bird fashions its dwelling, and the structural shell was lined with blankets and various materials found on site. Informing this work was a desire to give the viewer the chance to enter an allegorical space with strong anthropological and historical-cultural references such as birth (the womb), protection, the home, and, as with all round or dome-shaped architecture, a direct reference to the universe and the existential.

Some two meters in height, the sculpture comprises a patchwork quilt of austere gray, black, and linen-colored blankets. They look as if they have been scavenged by a giant magpie from some kind of educational or penal institution. Stitched together into a patchwork, they overlap to create the soft shell of what looks like both an egg and a nest. The metal ladder leading from the ground into a hole at the top of the structure acts as a visual and psychic enticement. Inside, this cocoon lined with soft fabric—the perfect treehouse, a child's dream come true—offers a womb-like hiding place. Despite being an enclosed space, these infantile associations are also liberating. The title and the egg-like form of this structure reinforce the sense of a space for rearing the young and nurturing new life. Yet the time must come when the fledgling is pushed out by the parent and forced into flight. This sculpture offers a retreat, yet also the possibility of new life and the necessity of departure, of moving on.

Voyages must end with arrivals. Like Daniel Defoe's castaway, Robinson Crusoe, Ratti orientates herself by mapping new surroundings and creating a secure habitat. She looks for clues in the ephemera of social rituals, in material cultural, and in geographical phenomena. The work *Urban Landscape, Early Morning, in Autumn* (2003) was made after the artist had moved to London. It is constructed from wooden palettes used for shipping crates. These provide a literal and metaphoric platform for a series of natural and cultural artifacts that oscillate between exterior and interior. ". . . it's like the way you look at a city, a town, at urban space, but there is also the idea of home and of home life."

Nido (Nest), 1999
polyurethane foam, blankets, cloth, felt, metal, sleeping bags, foam rubber, light bulbs, audio system, music
320x ⌀160 cm

The palettes are arranged in a rectangle that acts as a horizontal frame, recalling a raft. The climatic, phenomenal, material, and olfactory elements of the landscape are represented by a whirring fan, recordings of bird song, bags of fall leaves, pots of rosemary. Coat stands and lamps provide a vertical axis that also echoes the high-rise apartment blocks outside the artist's London studio. These elements are composed alongside long cushions covered in richly decorated fabrics, rugs, an empty birdcage, and a television set. Again, the piece is haunted. There are the ghosts of London birds captured on sound as they erupt into the dawn chorus; the image of a puppy playing on the TV screen, filmed as it explores this structure; and a human presence. Overlapping rugs and cushions create "divans" draped in patterned textiles that originate in Africa and India, vestiges of a colonial past and emblems of London's multiculturalism. They are arranged so as to invite not sitting, but lying down, in the manner of an Odalisque. They evoke not only eighteenth-century Orientalism, but of course, Freud's couch.

Nido (Nest), 1999
detail

We know that this is someone's habitat—her coat hangs on the stand; we hear what she heard, early one morning; we see a home movie of a pet; we see an inner sanctum. *Urban Landscape, Early Morning, in Autumn,* looks outwards from the perspective of a voyager mapping her co-ordinates. At the same time we look into a life. Ratti also offers a place of meditation and time travel—to cultural and personal origins.

This idea of the temporal quality of the material worlds owes much to Robert Smithson and his "displacements," a legacy Ratti makes overt in a project for the Gwangiu Biennale in Korea. Echoing Smithson's rejection of representations of the landscape in favor of moving the topography of the land into the gallery itself, Ratti arranged a heap of Korean soil into a map of North and South Korea. Smithson sought to orientate his geologies by intersecting them with mirrors that reflected the surrounding space into the work; and represented both the displaced "geology" and the context in which it was presented, as image. Ratti replaces the mirror with a fluorescent sheet of orange Perspex. She also buries cultural and technological artifacts into the soil, such as books, toys, and spotlights. Again, the point of view is of looking down from above and of gaining perspective through distance. The soil is all the same color. Yet the found objects gathered by the artist from shops and markets around the site of the Biennale bring representations of ideology, narrative, and political conflict into this process of mapping.

All of these elements come into play in Annie Ratti's project for the White Box in 2006. The basement of a high-rise building, this gallery is anything but a white cube. We enter along a ramped walkway and turn the corner to find ourselves standing on the edge of a kind of pier below which the floor drops away to form a deep concrete tank. The pier extends into the center of the space supporting two columns. A third column stands alone, metaphorically out at sea. Ratti exploits the associative potential of this resolutely functional structure. At the time of writing, Ratti plans to flood the space, reviving the notion of the pier as a point of departure that also offers the visual promise of a prospect or horizon. A view will indeed be provided by a film projected onto the water and the walls of this subterranean space. Shot in New York, it is Ratti's remake

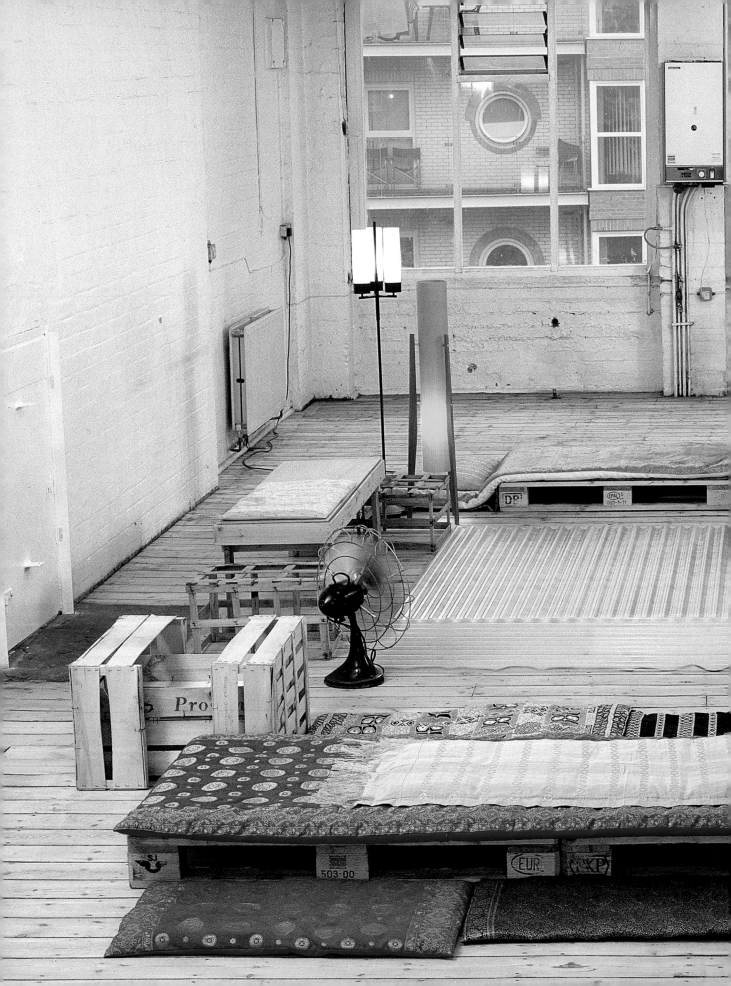

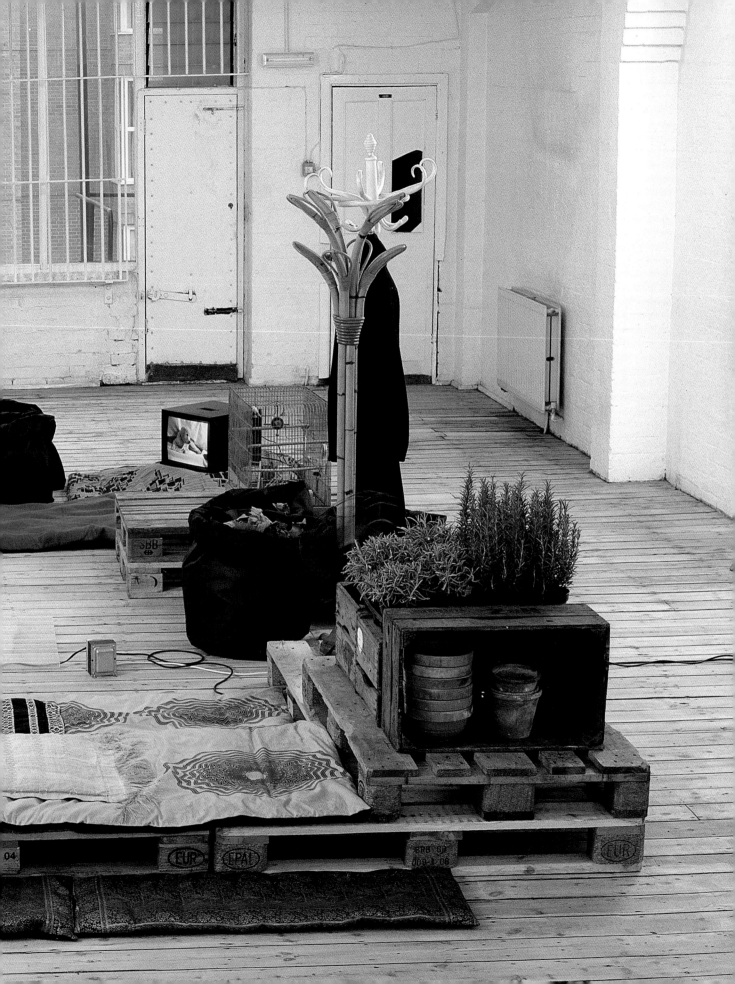

of Albert Lamorisse's *Le Ballon Rouge* of 1956. Her camera follows the progress of a red balloon through the skies of Manhattan, blown and buffeted skywards. In the original film, a small boy lets the balloon lead him through the streets of Paris and into a series of adventures. It is the situationist concept of the *dérive* of a psychogeographical experience of the city dictated entirely by chance. If not our bodies, then our eyes will follow the red balloon on its adventures, the visual pleasure of its absurd lightness and jolly color, made all the richer by memories of play and celebration and escape.

The White Box project operates on several levels. Ratti is herself a migrant in this city of migrants. She does not use the White Box as a white cube, ignoring its strange architecture by installing discrete objects or images. Instead, she uses it to narrate the historical and topographical narratives of Manhattan—as

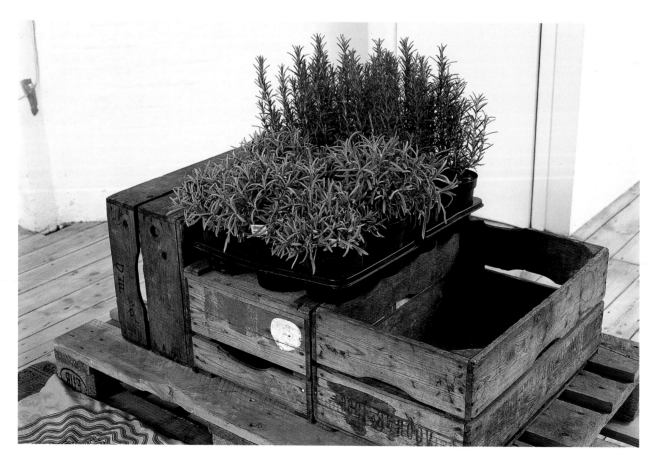

an island; as the historic entry point for European refugees from the "old world" and contemporary economic migrants from the third world; as a concrete canyon. She reveals the space as the basement and foundation of a huge building. This psychic weight is, however, lifted by the fragile ephemerality of the balloon. Annie Ratti's White Box project is both the point of arrival and of departure.

* All quotes are from the artist, in correspondence or conversation

Preceding and current page: Urban Landscape, Early Morning, in Autumn, 2003
pallets, cushions, crates, lamps, plants, fans, video
665x400 cm

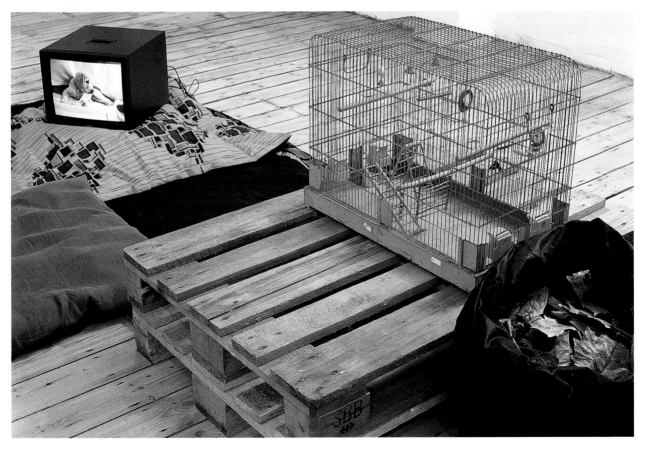

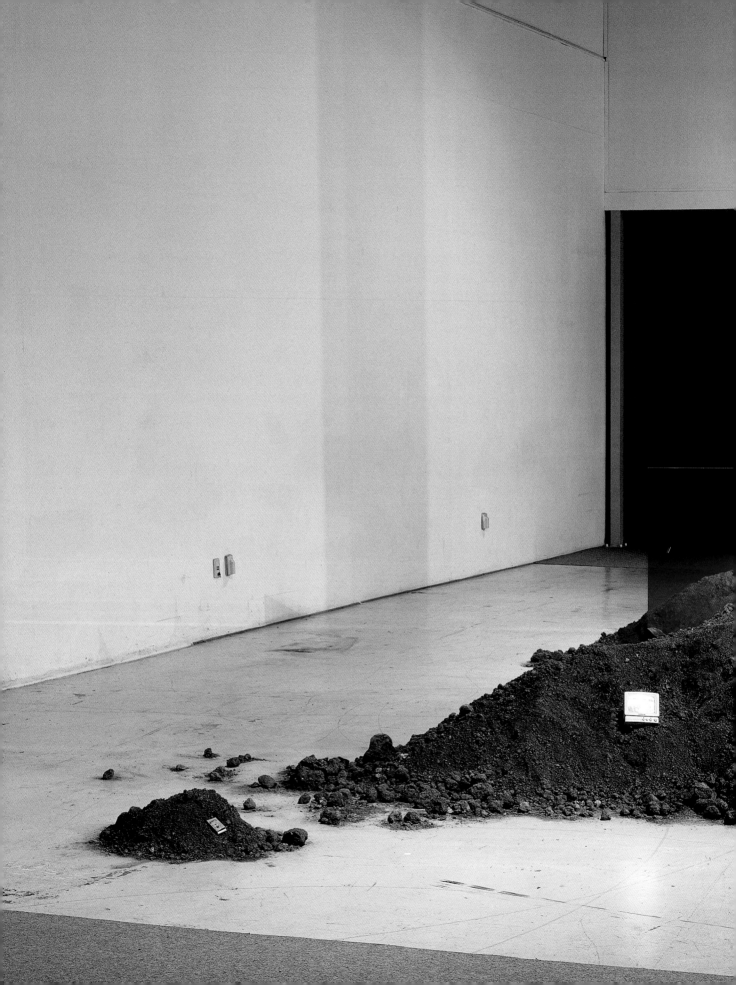

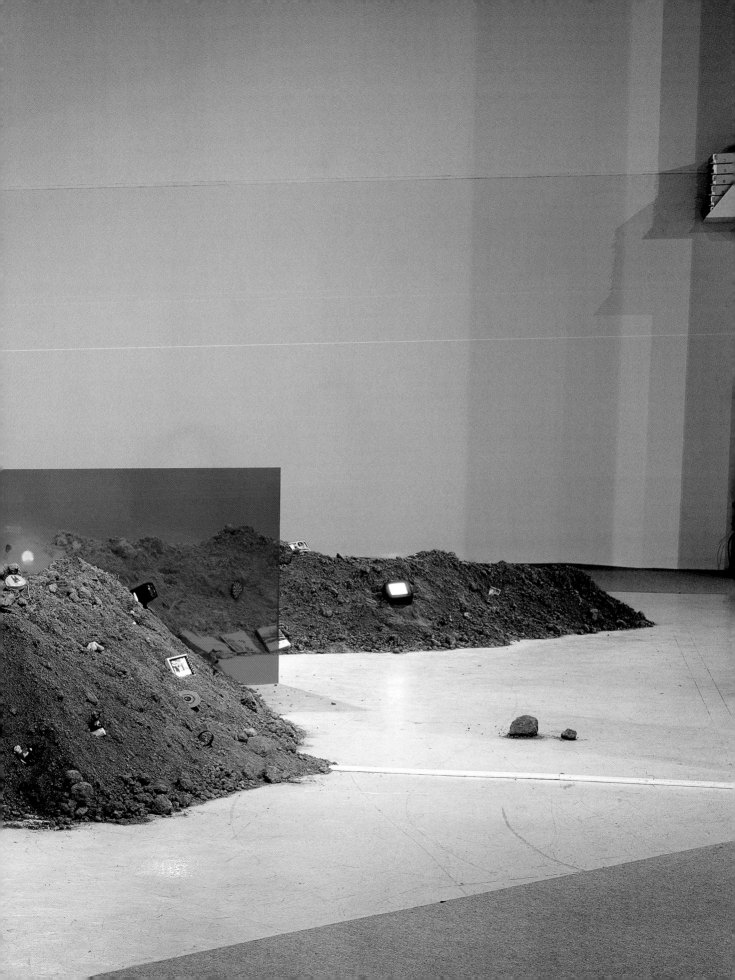

Preceding and current page: Homage to Korea, 2004
earth, perspex, slide and security video monitors, found objects
from North and South Korea
1100x500 cm

Following pages: Evaporated Sea, 2006
salt, wooden deck, video projection 12 min.
site-specific

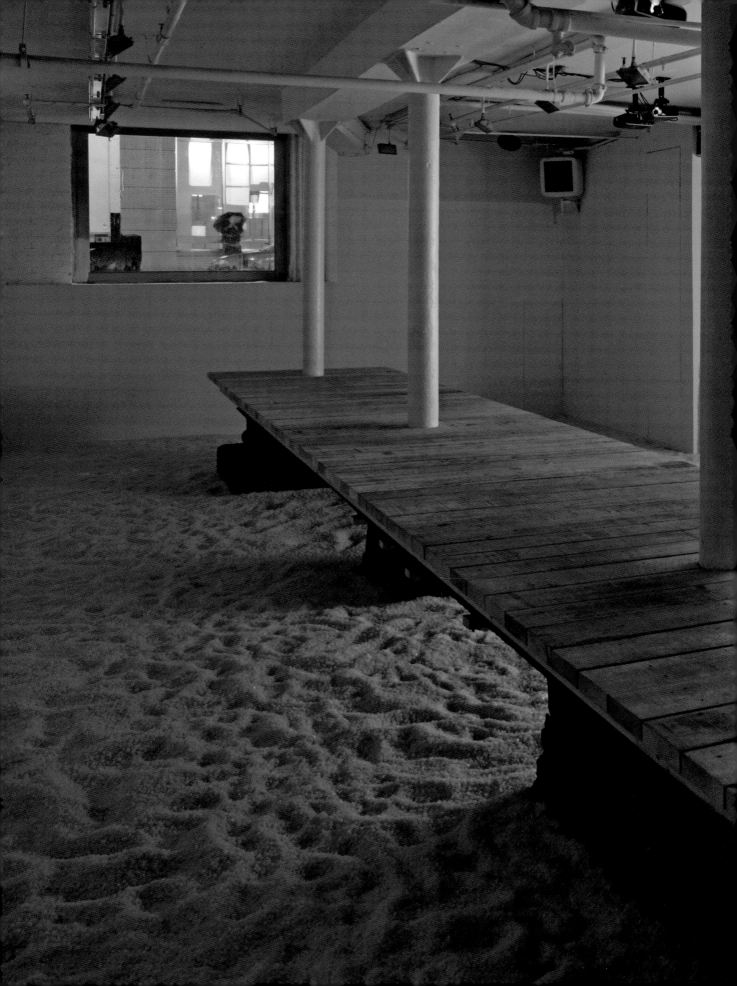

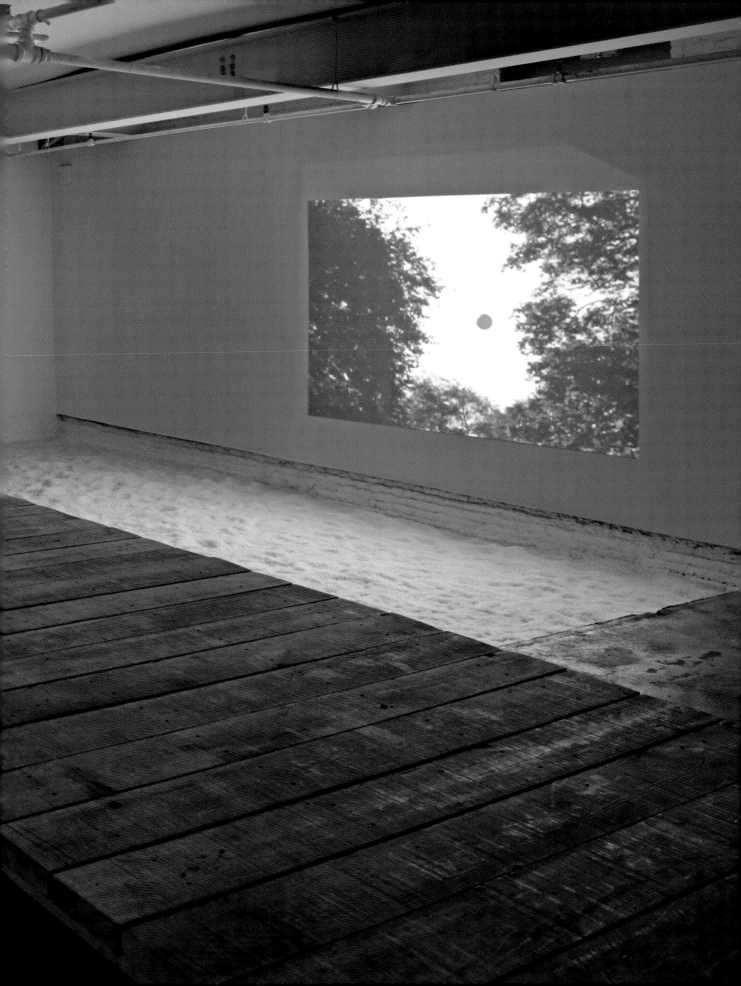

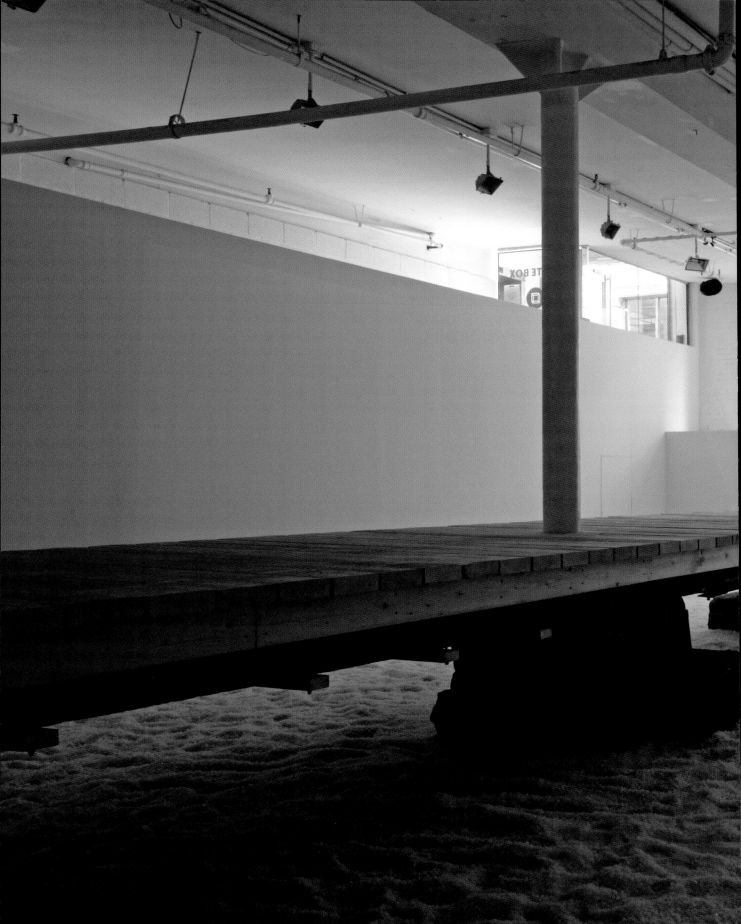

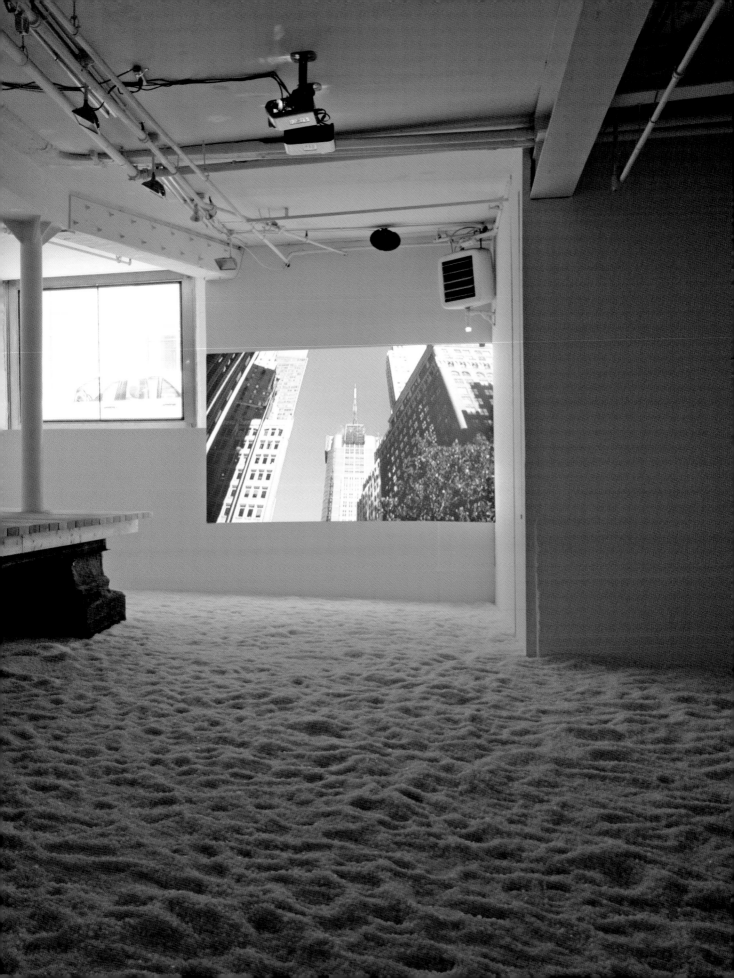

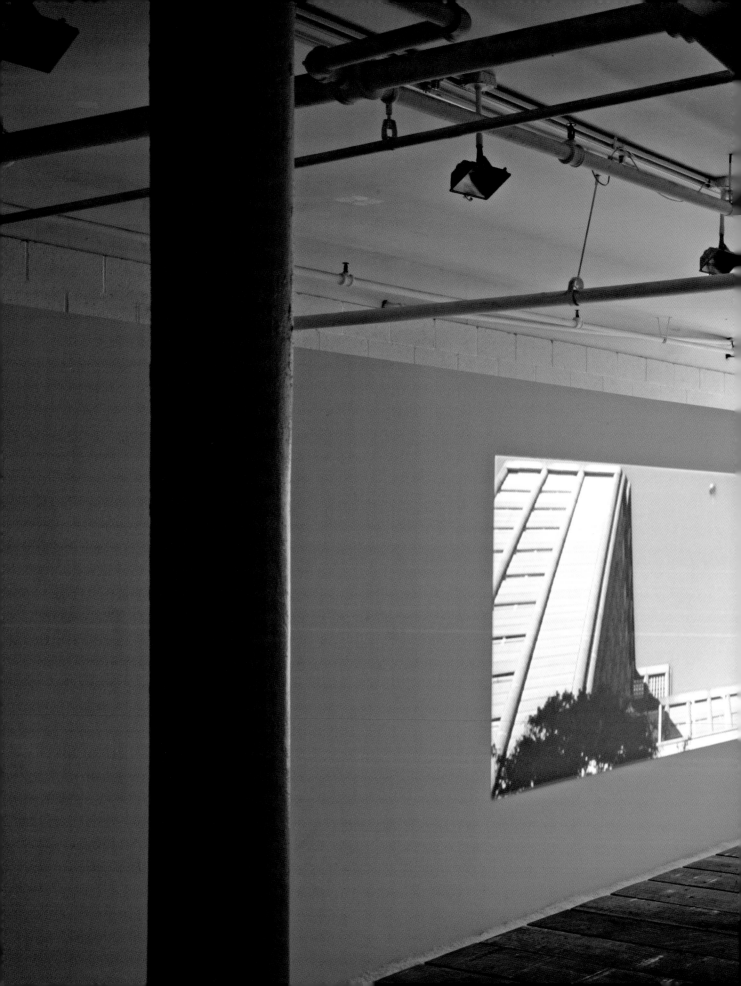

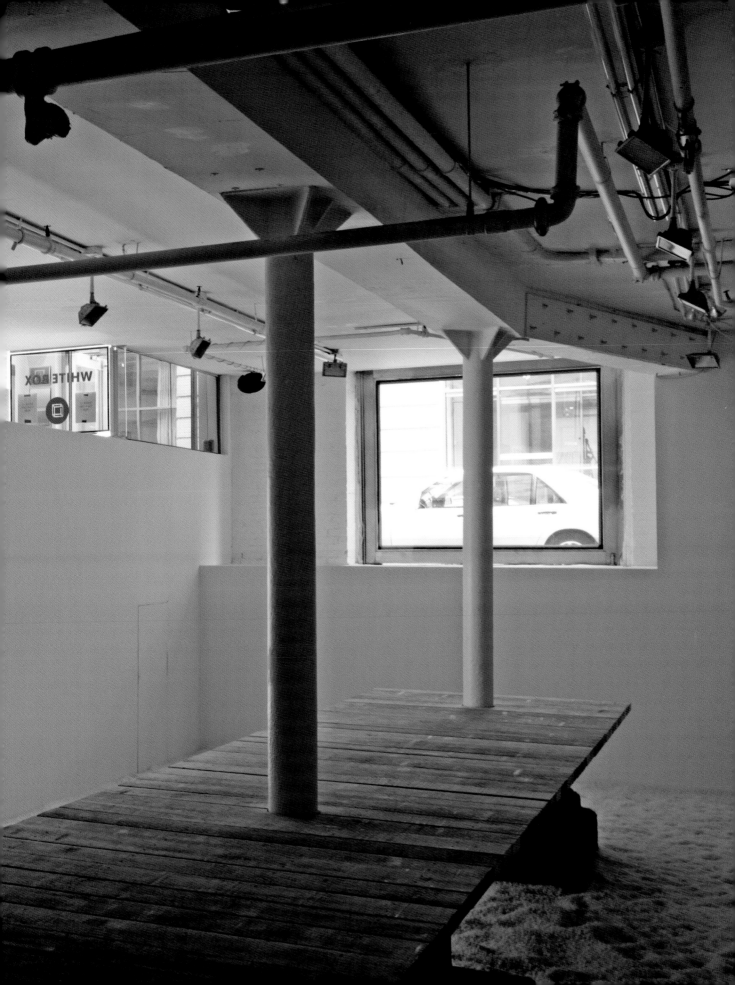

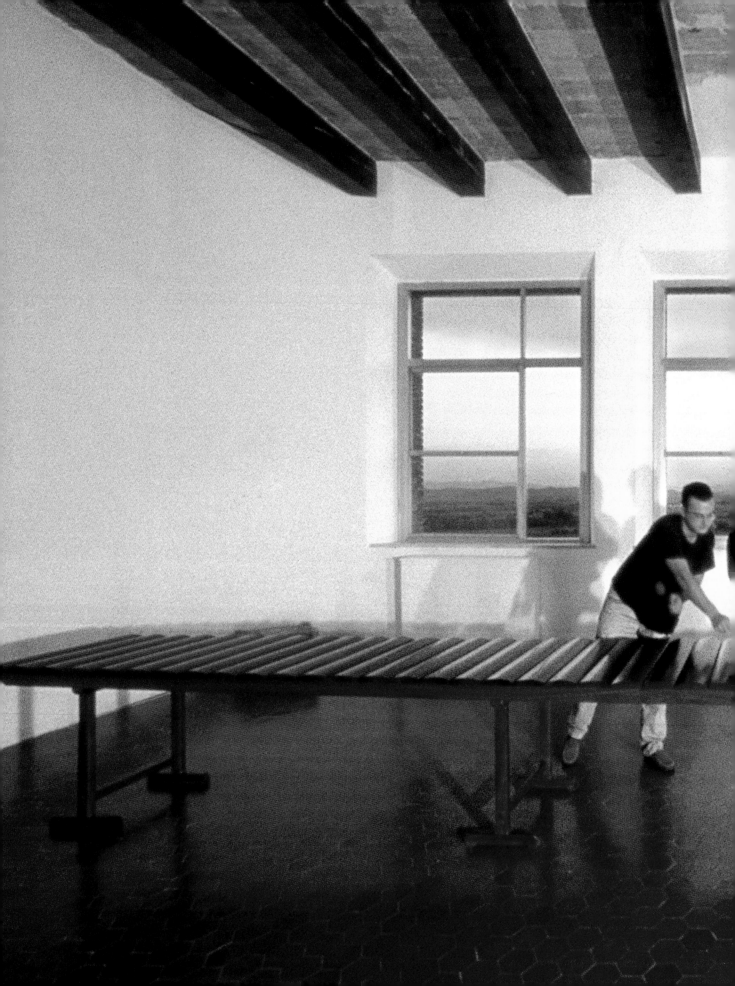

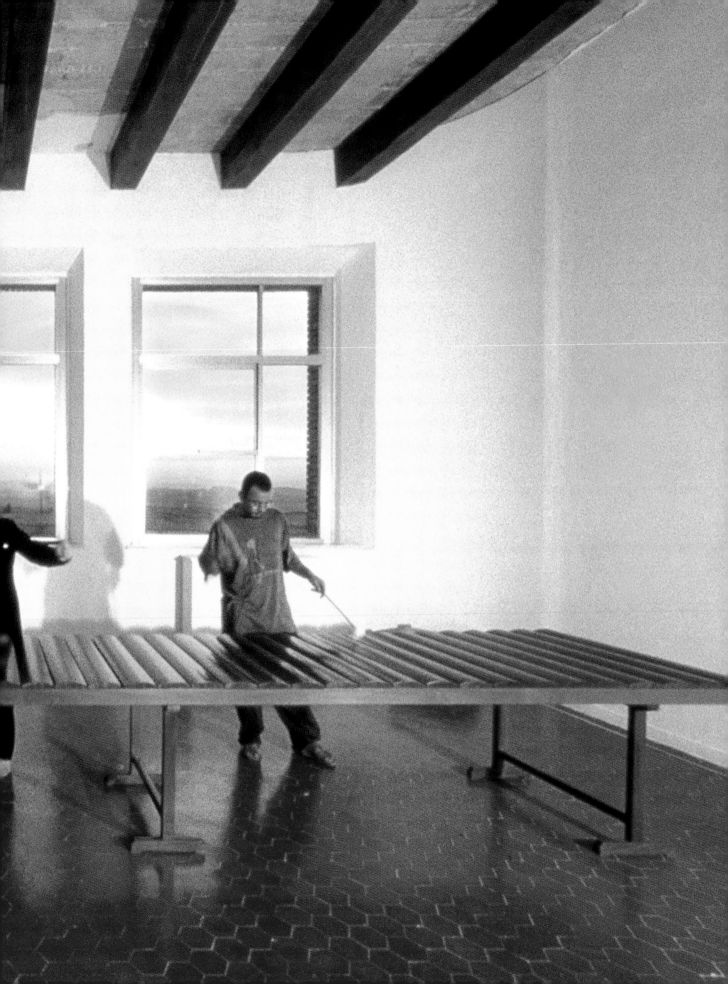

Annie Ratti
by Giorgio Verzotti

The huge xylophone that Annie Ratti once had made exceeds the musical instrument's normal dimensions, but the excess is not due to an oneiric projection, a suggestion deriving from surrealism. The instrument, perfectly made in terms of functional effectiveness, i.e. for the purpose of making music, takes on abnormal dimensions simply because it has to be played by many people. And the many foreseen by this exaggeration of the normal dimensions will not necessarily be musicians, people that know how to work with the sonority that can be obtained by striking wood. This xylophone is built in such a way that many anonymous participants can use it as they think fit, obtaining the most unpredictable sounds from wood—perhaps a tremendous cacophony every time they try to play, perhaps a combination of unordered sounds that counts as possible music, as random, but effective, valid scores.

The effectiveness depends on the open structure with which the work identifies completely, a structure that anticipates a number of participants ranging from zero to infinity. It is also possible for it not to be used (and then it can be considered an artistic fact, resolved entirely on the visual plane), or else it can become a fulcrum, a center around which countless possibilities of action radiate. It is important to note that in this case the work gives up its excellent "objecthood," becoming a pure instrument that addresses another, a pure device for creating an event or process.

Annie Ratti's works are very often conceived and constructed like this xylophone, which is one of the most advanced points in an oeuvre that now spans more than twenty years. In other words, her works are made in such a way as to acquire meaning from the fact that they are enjoyed on a level that goes far beyond looking, with an attitude that questions our very exis-

tence in the world. Above all, they are made so that they "disappear" as such and become opportunities for collective use that introduces or seeks to introduce interpersonal relations.

Not that this characteristic exhausts Annie Ratti's investigation, but it is a fact that much of her work proceeds in this direction. This also calls for a certain coherence on the level of formal realization. Many of the works—be they sculptures or installations—are built as structures that conceal an inner core, a space that at first sight rejects pure observation. They play with the circularity or semi-circularity of surfaces, presenting a closed, deaf, impenetrable side to the exterior. One has to enter, walk, climb, or perform some action with one's body to get the work that lies within into focus. Thus one can get a view of what is inside that focus (the video with a child's face, for example), but above all one understands that it is only by "acting" that one gives meaning to the work itself. Meaning and form: a platform becomes a platform by being used to dance on, going far beyond its minimalist "look." A double semi-circular structure covered with soft white material can become a bookcase, while a structure consisting of pieces of cloth and tubes hanging from sturdy cables opens and changes shape when occupied by visitors who use it as a circular seating system.

The artist's attitude to this is very clear and radical: the work always comes from creative stimuli that originate in everyday life, in a direct relationship with the most "desublimated" reality, arising from the mere happening of events connected with existence. This origin and this dimension must not remain merely implicit in the work produced, but have to guide or direct it, as it were, in its openness to the viewer, an openness that changes from virtual openness to functionality and use, only acquiring meaning from the function performed and from use (otherwise, however elaborate, it remains a purely formal exercise).

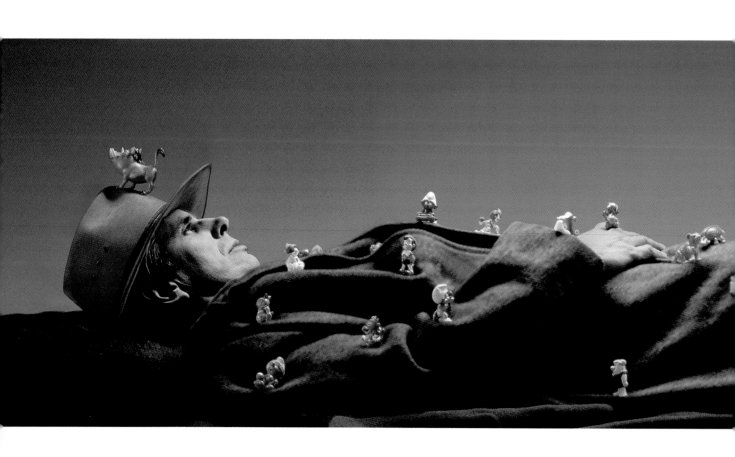

Land Man, 1999
inkjet print on paper
96.5x400 cm

As we have said, these characteristics do not apply to all of Annie Ratti's oeuvre, but they become a natural part of its spirit, its attitude, which is not contradicted by works with a different approach.

In the diversity and complexity of her work, one can distinguish moments of internal coherence. Corresponding to the series of works described above, which constitutes a driving center from which other directions and inquiries depart, there is another cluster of works that appears to be complementary to it. The first group of works designates the closed place inside which meaning is produced and which seemingly, as we have said, presents a "closedness" to the exterior, a closed surface with no handholds.

The other pole is that exterior, which the artist portrays with a particular appearance and in accordance with a particular rhetoric, almost always working with horizontality.

Photographs appear in her work, portraying male individuals lying down—a man enveloped in a heavy coat dotted with small toys, another man lying on a mattress and photographed from above, with the reproduction of his body resting on a real mattress.

There are also the words *I am hungry*, constructed with the kind of light bulbs used in illuminated signs, referring, like the photographs, to the marginal part of the city, the area inhabited by the homeless, where the distinction between open and closed, between private and public, is no longer meaningful. This other place, indicated as an urban space without distinctions or boundaries, without structures that are not precarious, is presented as the negative dimension of solitariness, of existential drift, as the despairing "outside" to which the design of art represents an alternative. Annie Ratti's work is strongly involved with the perspective of design, the work itself is always a design of inhabitability, conviviality, and interrelation,

Piste de dance (Dance Floor), 1997
installation view solo show Magazin 4, Bregenz
plywood, resin, metal
40x400 cm

44

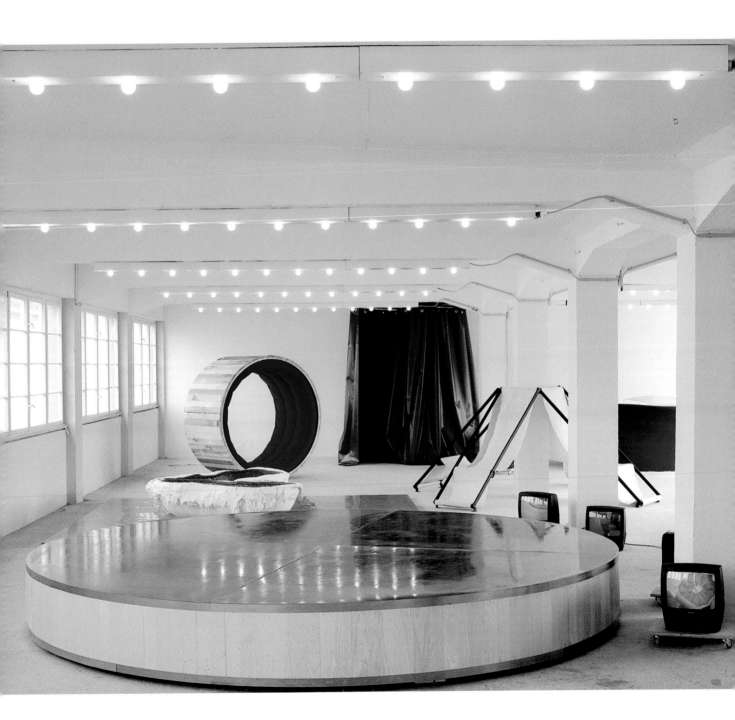

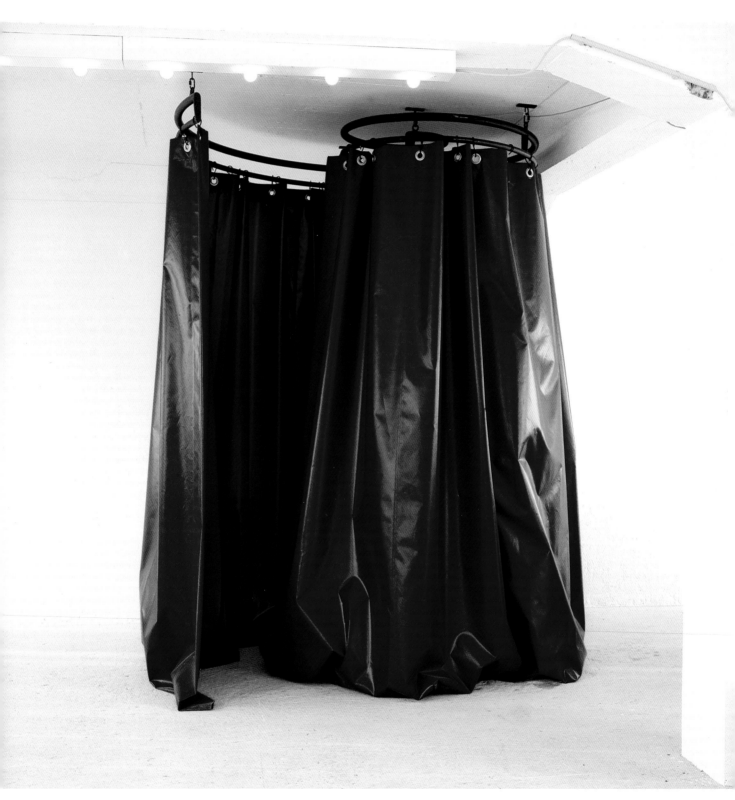

its structure sometimes presented as a kind of anthropometry, and it is studied to accommodate the human body, to take care of it. Thus it is the area of shared intimacy, of subjectivity rediscovered and placed in relation to the other, and its affirmative nature, its propositional meaning, is strengthened in relation to the images of the subjective diaspora.

In her more recent works, these two dimensions seem to meet and the investigation takes on new values. The installation *Urban Landscape, Early Morning, in Autumn*, for example, marks a further step in the direction that we have indicated. It consists of a number of heterogeneous materials arranged to form a rectangular structure that encloses a closed space inside it. The structure is low, made up of mats, textiles, boxes of fruit, pots with aromatic plants, lamps, hat stands (which vertically enhance the general "ground-hugging" impression), and chairs. These are quite clearly pieces of furniture, a set of chairs that the public is invited to use, and as a whole they inspire ideas of relaxation, abandonment to rest, or contemplation of nature. There is also a video showing the development of a puppy and a recorder playing birdsong, as if to say that nature is considered absent. It could be a nomad dwelling or a makeshift structure that the homeless have made in a deprived area of the city, or it could be a furnishing scheme—a strange one, but still suitable for fitting out an interior. The work, with its collection of objects, delineates a space that we cannot define, one that belongs to both the exterior and the interior dimension. The title emphasizes that the two polarities that elsewhere we have found acting as dialectic opposites here merge together and create an ambiguous, precarious, changeable spatiality, which may mirror the identity that the artist intends to take as her theme, one that inhabits these places and uses these objects.

Perhaps Annie Ratti is directing a message to us that seizes upon ambiguity to provide an indication, a response to the existential queries that all her work raises: it is necessary to be ambiguous to overcome the disintegration of subjectivity; it is necessary to accept multiplicity to overcome the diaspora.

In this fusion of external and internal, the work she stages becomes a metaphor of a self that transcends itself, going beyond its own limits, perhaps thus also succeeding in overcoming the contradictions that pervade its existence.

Cabina (Cabin), 1997
metal, PVC, monitor, *You and Me* video (loop)
300x ø190 cm

47

The Giving Art
of Annie Ratti

by Eleanor Heartney

On the margins of the booming art market, a small but influ-
ential group of artists has been exploring a different kind of
relationship between artist and audience. They reject the con-
ventional notion, described in disconcertingly mechanistic
terms by the formalist critic Roger Fry, that the artist should be
thought of as the transmitter, the art object the medium, and
the spectator the receiver of the meaning of a work of art. In
this view, the viewer's task is simply to clear away the messy
static inhibiting clear reception of the artist's ideas.

Opposed to this is the vision of the artwork as an action and
members of the art audience as active participants who com-
plete the work. In this view, the act of reception is not a passive
one, but instead involves the creative engagement of all parties
concerned.

This idea is not new, of course, and has manifested itself period-
ically in art over the last hundred years. The philosophical basis
for the dematerialization of artwork and the valorization of au-
dience can be found in Roland Barthes' influential 1977 essay
"The Death of the Author" (which, he promised, would make
way for the birth of the reader). The idea reappears in Joseph
Beuys' concept of Social Sculpture, designed to transform soci-
ety through the breakdown of distinctions between artists and
non-artists. Audience participation is central to movements like
dadaism, situationism, and Fluxus as well as the performances
of artists like Vito Acconci and Chris Burden. Recently, it has re-
ceived renewed scrutiny under the label "relational aesthetics,"
a term coined by French critic Nicholas Bourriaud.

This tendency takes many forms, ranging from confrontation
to collaboration. One of the most radical of these is the notion
of art as an act of generosity, in which artists conceive of their

work as a gift to the audience. They may, like Rikrit Tiravanija, serve it up in the form of a meal to gallery visitors; they may, like Felix Gonzales Torres, provide "accumulations" of candy or printed posters for viewers to carry, or they may, like Annie Ratti, create works that provide spaces for meditation or situations for social interactions between people who might otherwise never connect.

Ratti uses objects imbued with associations of daily life—among them chairs, tables, beds, and bookcases. Her sculptures and installations may incorporate found objects, but more often they are specially fabricated to accentuate their potential for social use. For instance, *Nido* (1999) is a work that was originally installed in the woodshed behind the house of an artist friend. Pieced together from a patchwork of blankets, foam, felt, and other fabrics, it suggests a giant bird's nest that is suspended from the ceiling and accessible by a ladder. Inside are all the comforts of a hideaway—including sleeping bags, mattresses, light bulbs, and an audio system. It speaks to primitive desires for seclusion and security, while its womb-like space references everything from the secret colloquia that take place in children's tree houses to the communal lifestyle practiced in mud plastered aboriginal dwellings.

A similar principle is at work in *Six Pants* (1999). This consists of a set of canvas and metal chairs connected to a set of pulleys and elastic cables that allow a participant (with Ratti's work the term "viewer" no longer seems appropriate) to lean back as if in a chaise lounge. One of the most striking aspects of this work is the difference between its inhabited and uninhabited appearance. When not in use, it presents a set of stiffly vertical elastic sheets, but when participants take their places, it seems to open up like petals of a flower, creating an intimate conversation circle.

Six Pants was one of a number of interactive works presented in an exhibition in Bregenz, Austria, that also included a platform in the form of a circle of camembert cheese upon which people were encouraged to dance, an oval ping pong table that eliminated the sharp edges normally encountered during the intensity of play, and a pair of pod-like foam seats into which one could sink as if into a hot tub. A further element was a faux fur covered circular bookcase that is open on two sides to accommodate users. Within its curving interior, bookshelves form a spiral configuration, giving the structure a sense of dynamic movement. As part of the exhibition, Ratti placed a table and chairs nearby to encourage visitors to use the library.

Such works highlight another important aspect of participatory art. Because they engage the whole person, they go far beyond the mere visuality that formalists like Clement Greenberg used as the basis for critical judgment. Instead, Ratti's works appeal to all the senses—not just sight and hearing, but smell, touch, and even, at times, taste. They address the whole person and hence make the kind of disinterested aesthetic appreciation favored by Greenberg irrelevant and even impossible. Redefining art in terms of relationships rather than objects, works like these demand a rethinking of conventional definitions of art and aesthetics. The quality of the whole experience becomes as important as formal relationships of shape, color, and material.

One of Ratti's most comprehensive explorations of the participatory principle took place in the course of a 1998 installation at the Zerynthia Association's house museum in Siena, Italy. Ratti and a group of other invited artists decided to transform the former schoolhouse turned exhibition space into a series of interactive domestic environments. Working in collaboration with other artists, Ratti created a number of works for this exhibition. She and artists Mario Airò and Massimo Bartolini decided to construct a music room. Ratti's contribution was an oversized xylophone that could be played by several people at once. Ratti's collaboration with artists Bruna Esposito and Carmelo Zagari yielded a sleeping area, where visitors could climb into beds elevated on scaffolding. Esposito and

Six Pants, 1999
rubber cloth, metal structure, elastic string
six elements: 200x75 cm each

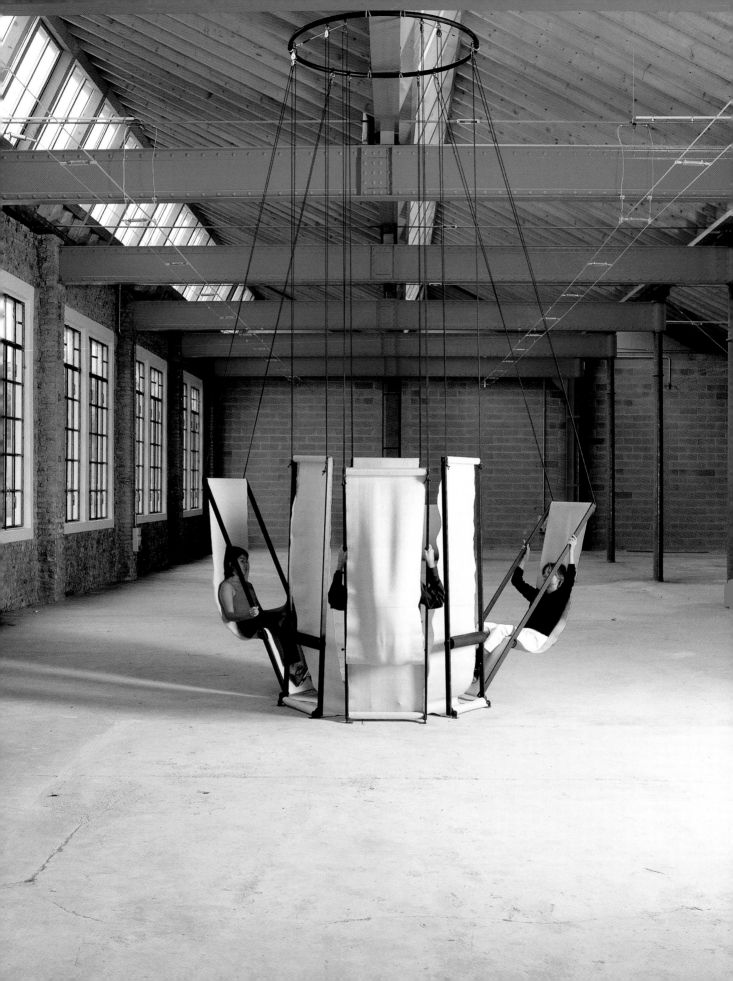

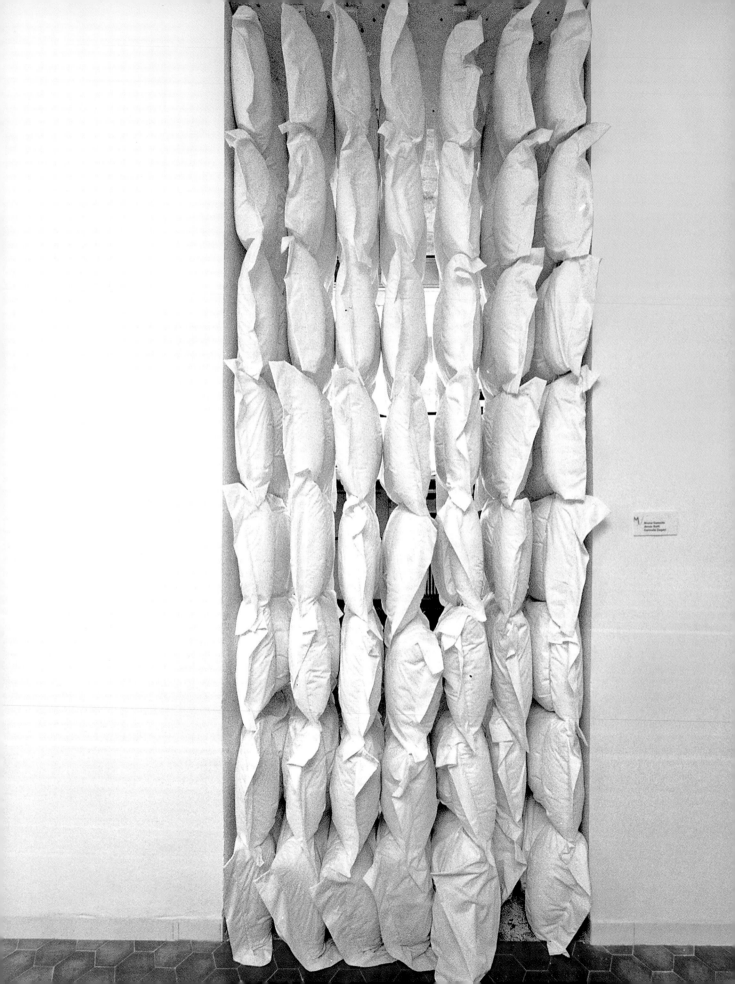

Ratti marked off the entrance to this space by filling the passageway with strips of white pillows. By requiring visitors to squeeze through these literal emblems of sleep, they sent a signal about the kind of space that lay within.

The notion of the artwork as a gift was eloquently explored by poet Lewis Hyde in his book *The Gift: Imagination and the Erotic Life of Property.* Hyde distinguishes between "gift economies" and "market economies" and suggests that genuine art partakes more of the former than the latter. He draws an analogy with tribal cultures where social bonds are created through the exchange of gifts rather than through the reduction of individuals to cogs in an economic machine. In this formulation, the artwork gains value as it moves through the lives of its creator and its users.

This notion of exchange, in which each participant both gives and receives something of worth, lies behind Ratti's ideas about art. As she says: "One of the vital necessities of art is to rediscover not only a function, but also a relation with reality, a relation capable of producing meaning, joy, pain, emotion: in other words, an art capable of giving something of itself, of producing relations with the world, of producing an other experience."

In her work, this experience takes many forms—it can, as in many of the works described above, involve the experience of communication between two or more audience members. In other works, the experience is more private, involving the creation environments where a single person may draw inward in a way rarely possible in the hectic outside world. For *This Is Not My Cup of Tea* (1998), Ratti designed a monumental cup cut away so that a single viewer can sit comfortably and observe the slowly moving globe placed on the floor nearby. The work offers a kind of out of body experience—allowing the visitor to drift imaginatively above the world as we know it.

Several works deal with political and social realities of human relationships. Though less overtly participatory, they draw audience members into a realization of their own social re-

La porta dei sogni (Dream Door), with Bruna Esposito, 1998
pillows, covers, string, lavender
360x80x120 cm

53

sponsibilities and interdependence on others. To create *Garry* (2000), Ratti placed a photograph of a homeless man over a real mattress and supplied him with a real book, thereby offering him a virtual solace denied by reality. *Fin de siècle* (1999), meanwhile, is a cry against man's inhumanity to man. Created during the Kosovo war, it consists of a large, orange, inflatable life raft whose center has been fitted with a documentary photograph of the horrific massacre in Rwanda. In a healing gesture, Ratti planted live barley designed to slowly cover this almost unbearable image.

With such works, Ratti pursues her conviction that art must be a part of life. This idea runs counter to the powerful economic and social forces that shape so much of the contemporary art world. But by stripping art of its status as precious object or luxury good, Ratti allows it to return in a form much more in keeping with our human needs for community, contact, and interaction.

This Is Not My Cup of Tea, 1998
resin, foam rubber, leatherette, lead, wooden frame, world map, engine, electric wire
95x90x180 cm

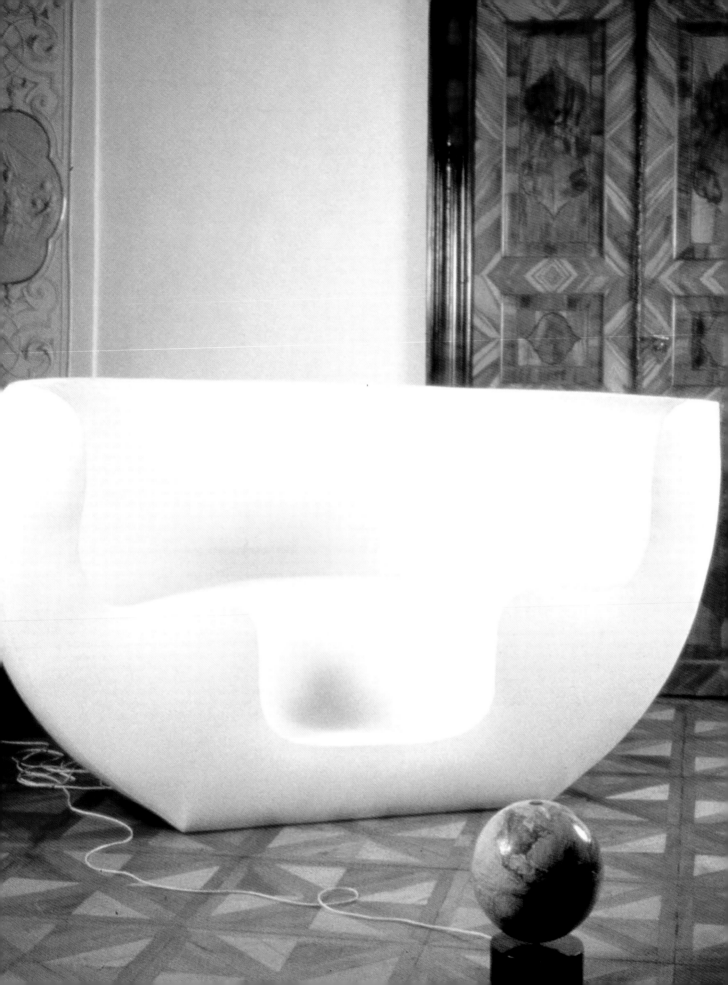

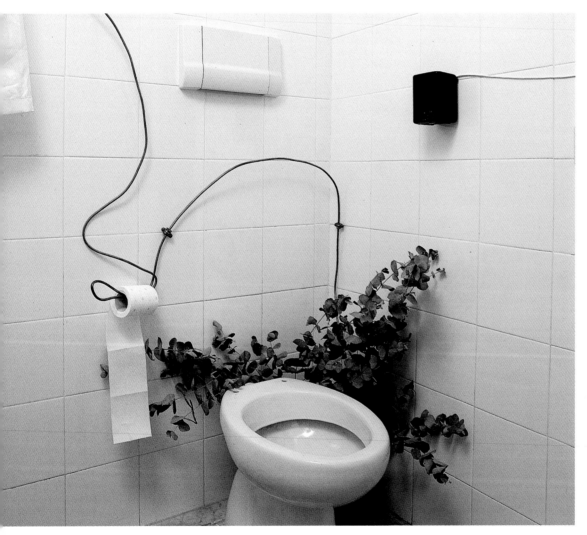

Il Tao dell'Amore (The Tao of Love), 2000
sensor, CD player, speaker
site-specific.

Right: Pontile (Pier), 2001
wood, portable radio
405x70x48 cm

56

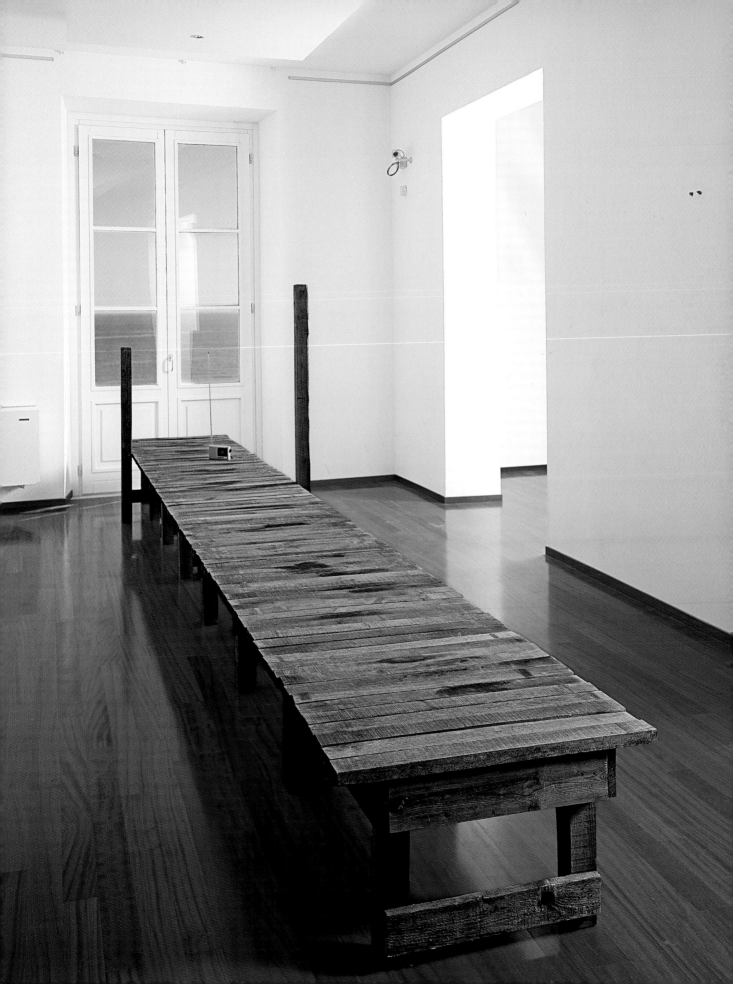

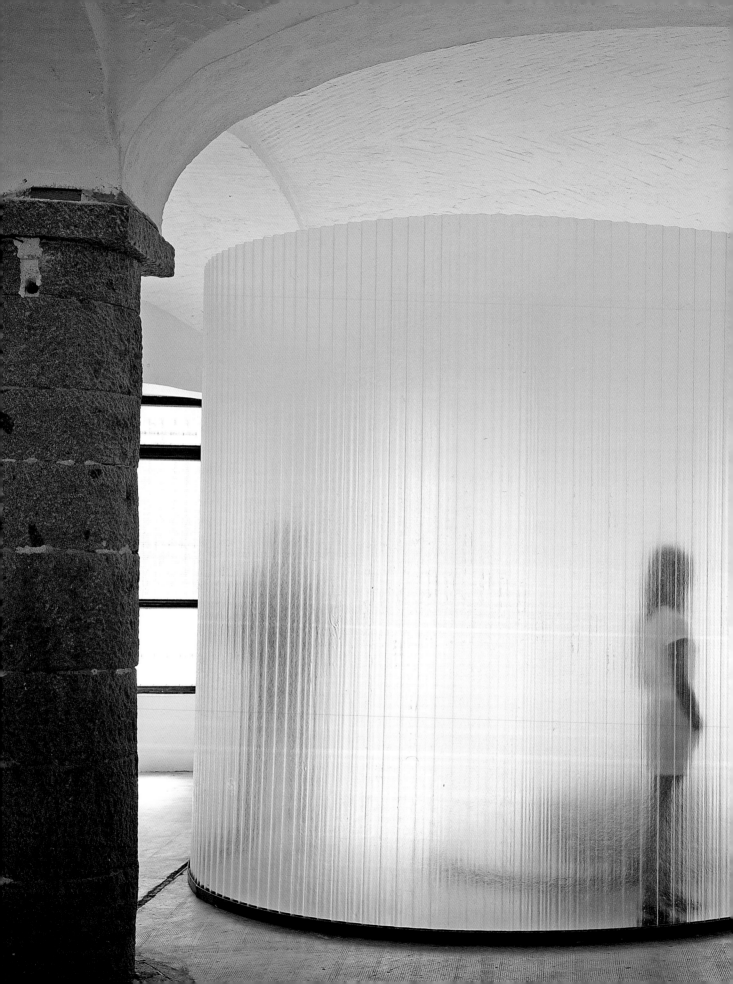

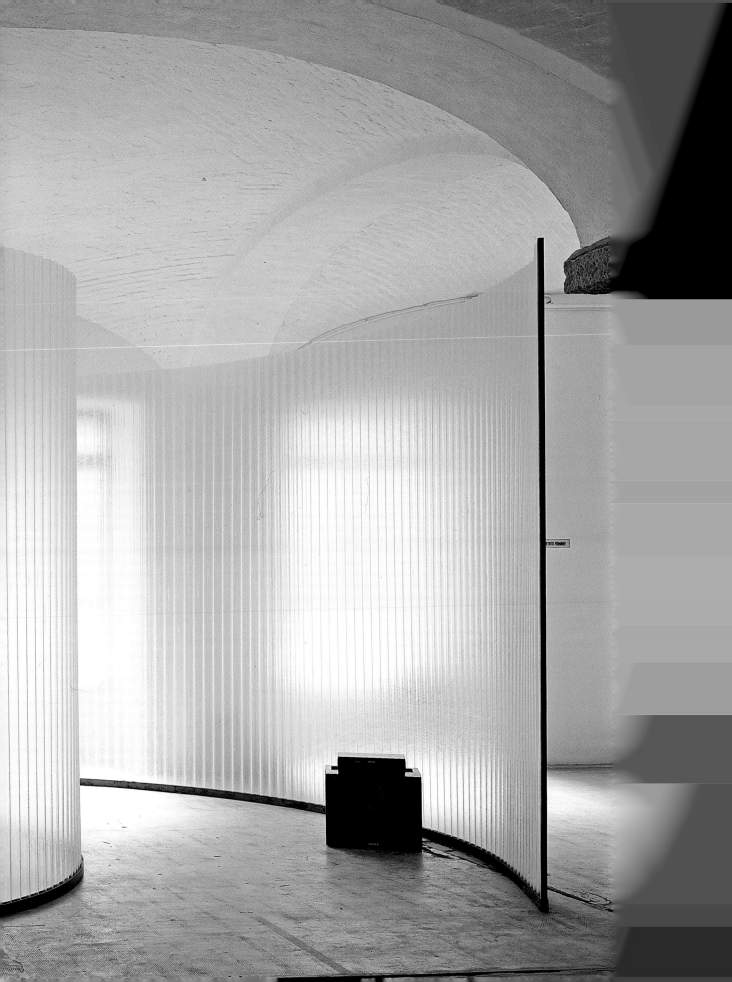

Spazio affettivo (Affective Space), 2000
fiberglass, metal, cradle, video monitor
ø600 cm

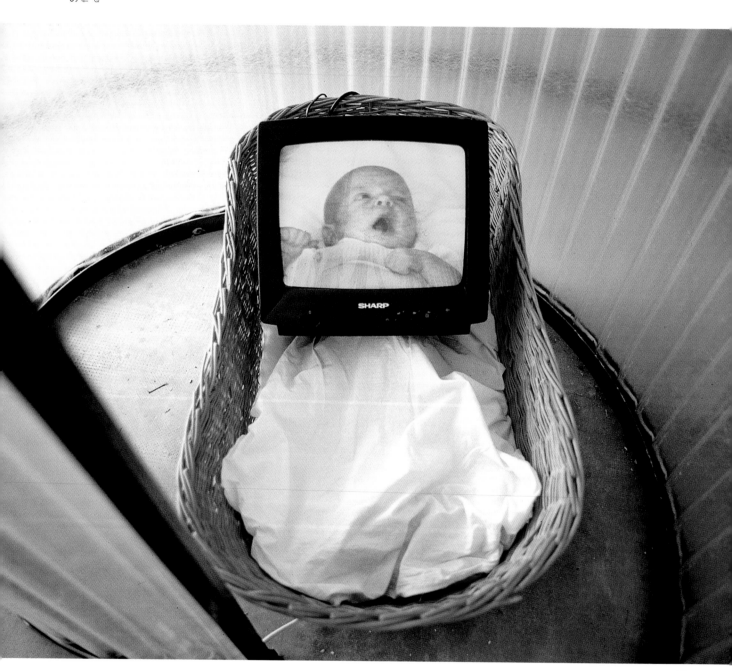

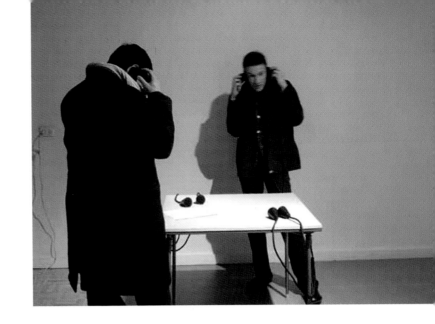

Where I Want To Be, 2006
fiberglass, rubber, four CDs,
four CD players, game table
75x75x75 cm

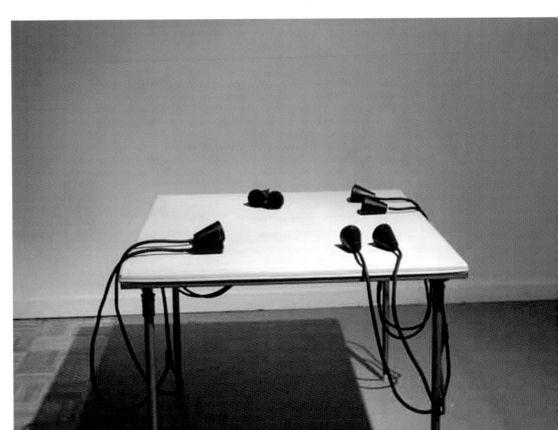

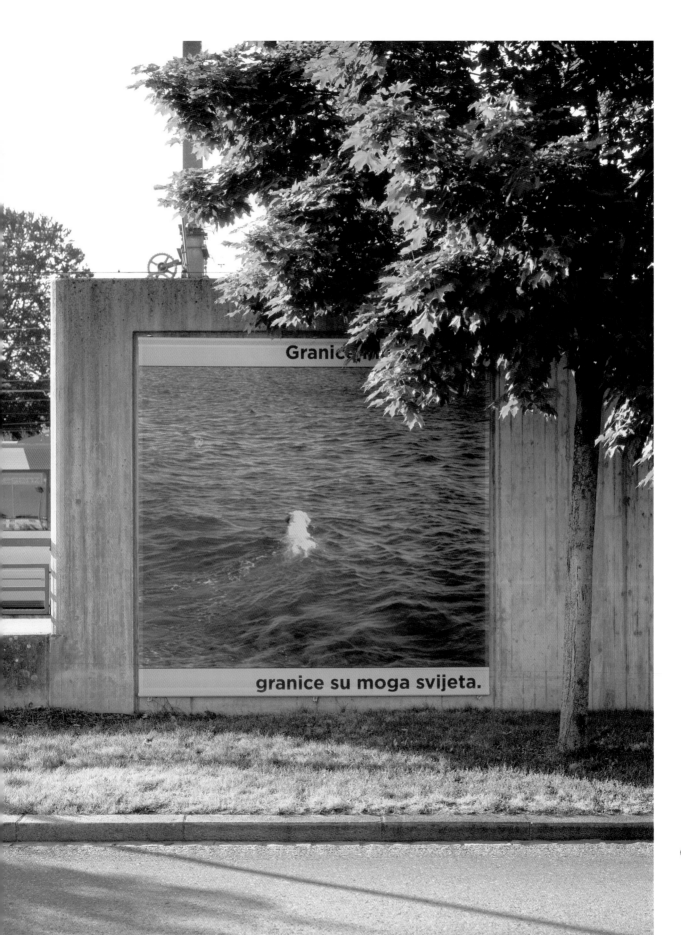

Granice...

granice su moga svijeta.

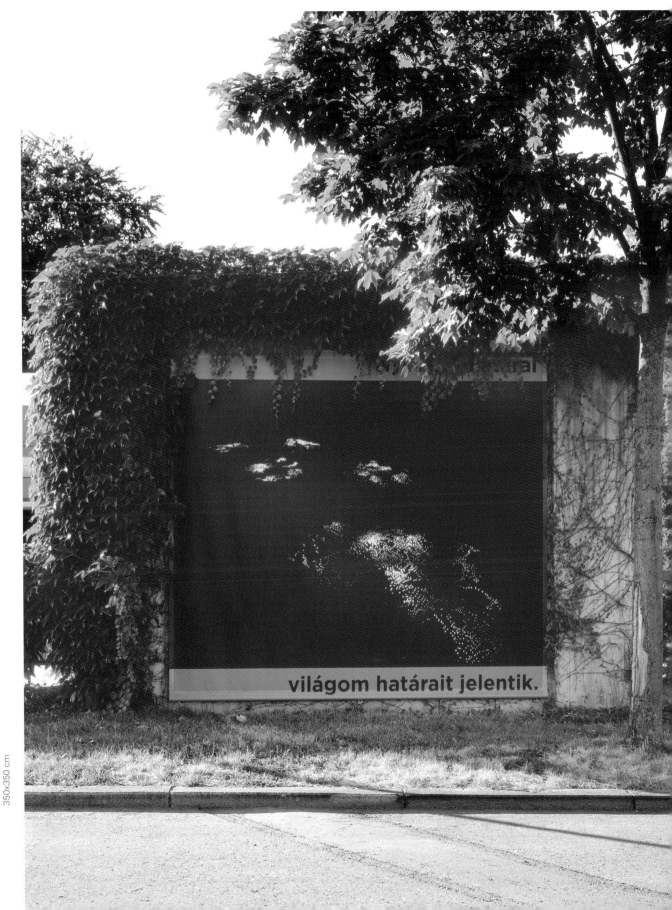

Current and following pages: Billboards: The Limits
of My Language Are the Limits of My World, 2006
six color prints on six billboards
350x350 cm

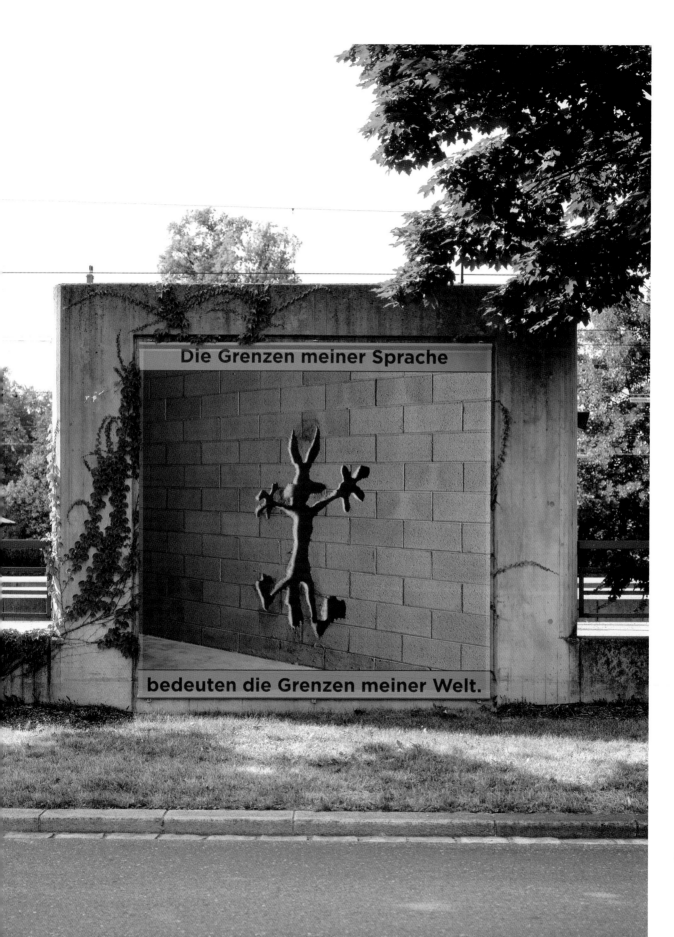

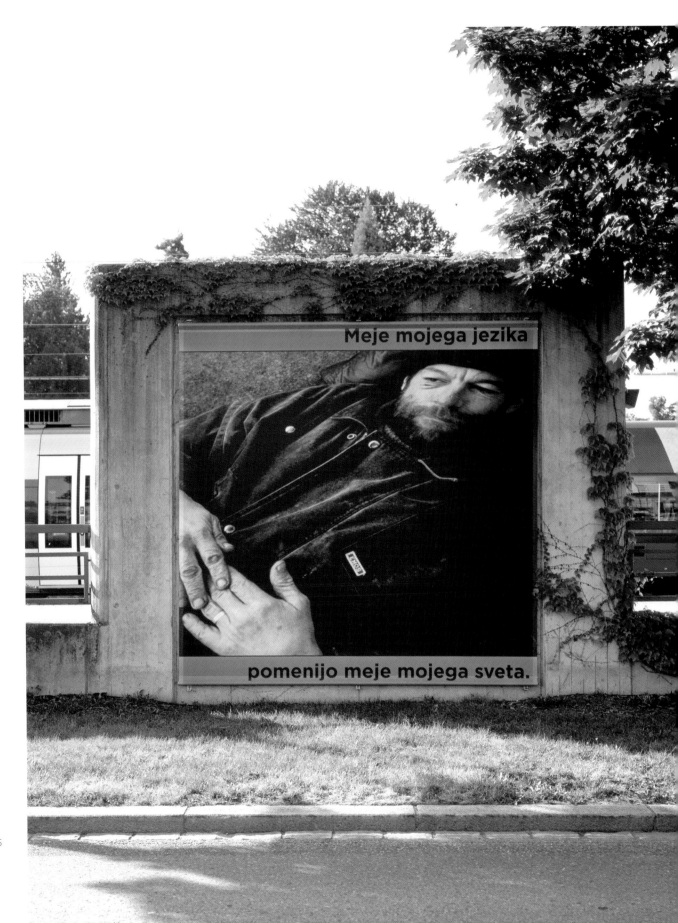

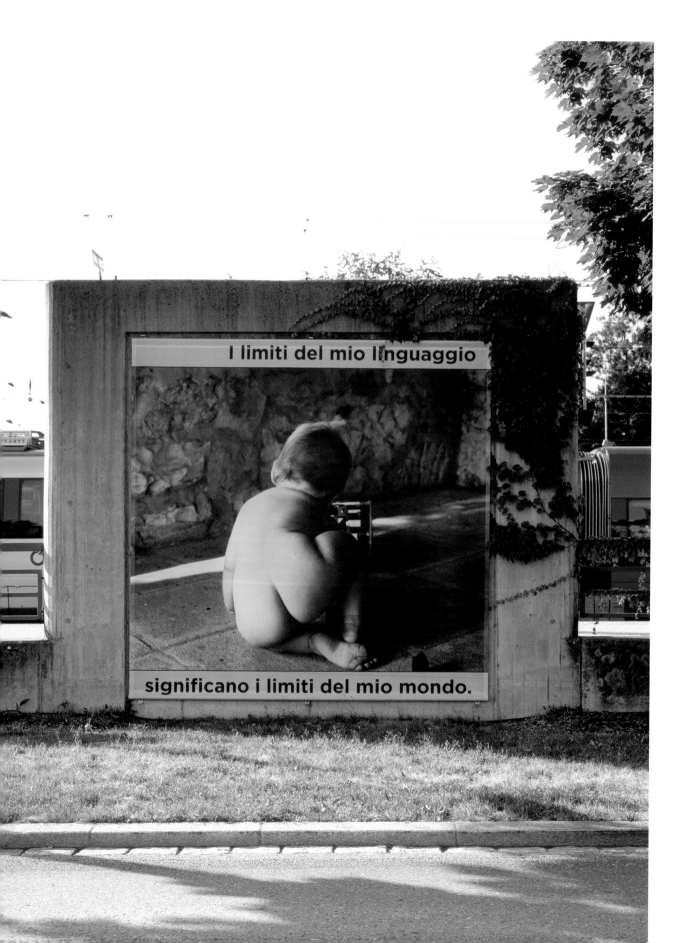

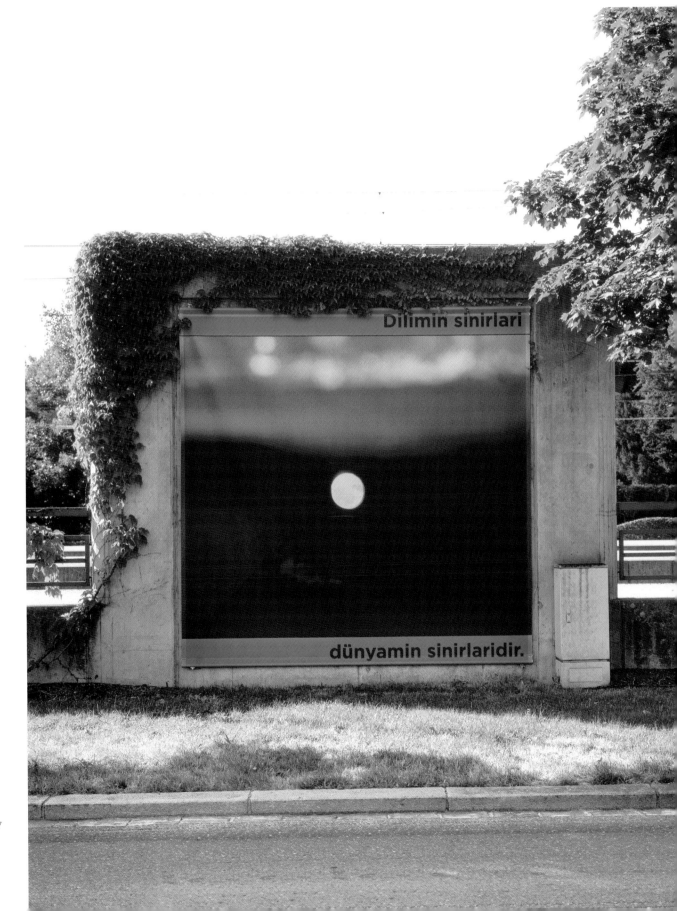

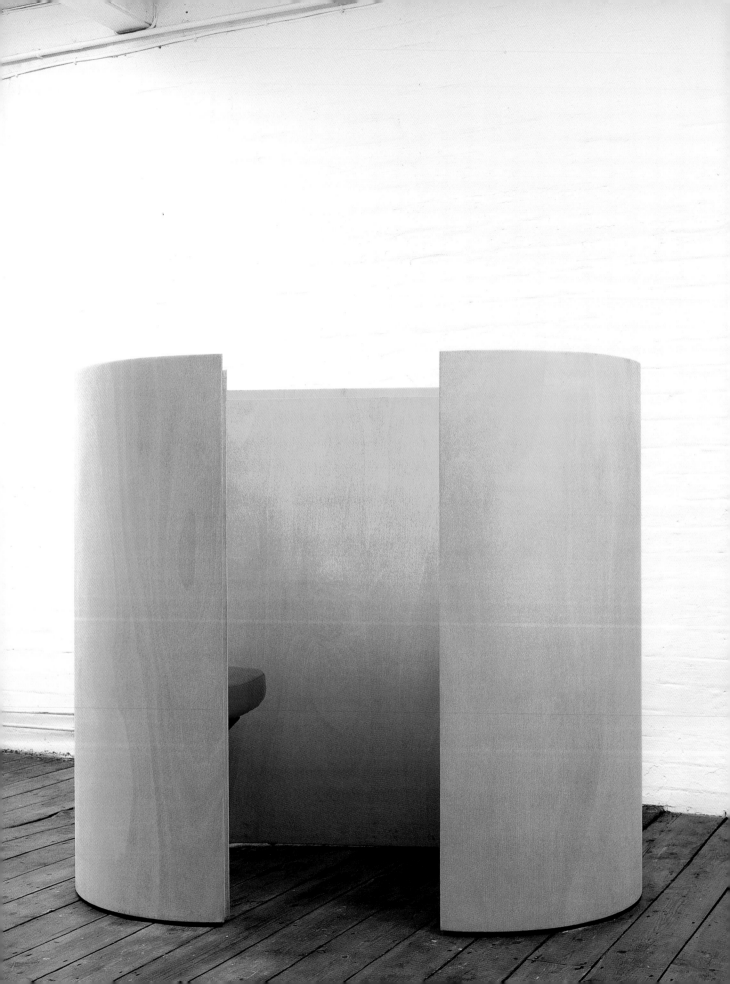

Fortiter in re, suaviter in modo

by Lea Vergine

Tête à Tête II (You and Me), 1999
wood, seats, leatherette
140x81x124 cm

"Fortiter in re, suaviter in modo" could not be more appropriate for Annie Ratti, whose work in the last twenty years has been permeated by a sense of strong determination and undeniable lightness.

Ratti expresses herself through her installations, mainly on the scene. She reveals and discloses, makes visible what we normally look at without seeing, all by means of a light-handed manipulation of appearance. To create means to represent physically what is secret and seductive. She does, indeed, simulate and seduce.

Every time a certain organization of the space—*Tête à Tête II, Urban Landscape, Early Morning, in Autumn*—that is, when perspective pretence is abandoned, something else occurs, which has a tactile quality: the physical presence of objects. The real world is but a *mise-en-scène*. Perhaps it is a simulacrum, which acknowledges the science of playing and of artifice. By exaggerating the appearance of the real world, Ratti dispossesses it, confounds it—doubts it, perhaps. This is one of the questions she raises in her work, just like the above-mentioned attention to the stimulation of the senses, to sensism, to the tactile sensation as a form of knowledge. I would say, an almost empirical experience to encourage thought.

Her objects are fancy images: *Tête à Tête* (1999) is an oval piece of plywood, half open, which allows two people to sit on vinyl seats in a secluded space reduced to the minimum, where their knees will almost inevitably touch. *Garry* is a picture laid on a mattress. An art book is open on Garry's lap, as if he has just finished reading it. But just as in Saint Thomas Aquinas or Duns Scoto, the objects are also "that to what the intellect, the clothes, and the actions lead." Therefore, Ratti's objects, in line with the modern philosophical interpretation, can be consid-

ered ideas or phenomena: they are, nevertheless, the final goal of the learning process.

As if using a fetishist metaphor—whose primitivism is familiar to the philosophy of magic—Annie Ratti explores rituals and symbols, focuses (or tries to focus) our attention on certain objects, and concentrates on strategic points: the bags stuffed with dead leaves, the empty fruit crates, the coat stand, the old bird cage, the functioning antique fans, the potted lavender and rosemary plants, the brightly colored oriental cloths, the same soundtrack of the birdsong. We watch *Urban Landscape, Early Morning, in Autumn*, whose stream can be diverted by a single person or by more people, almost like an anthropological ritual. The pieces of furniture—some found, some made up—are used as a means of communication and exchange. It is the innate human desire to plan (if it were not the desire of an adult, but an ancient desire stemming from childhood, it would be thus accomplished).

In *Due artiste* (1998), Ratti intends to urge the friendly relationship based on partnership, where everyone takes each other's part in many ways. Above all in *Urban Landscape, Early Morning, in Autumn*, sharing objects and ambiences, exchanging sensations or project ideas, being together in order to communicate each other's inner life, opening oneself to the same destiny, building communities within the world—these are all elements that mark a change in Ratti's quest: a hole in reality, a metamorphosis that is also ironic, maybe the secret of appearance itself.

Text published in conjunction with the exhibition held at the Italian Cultural Institute in London, January–February 2003

Due artiste (Two Artists), 1998
cibachrome on paper, audio system,
music by Geraldine Alles
280x185 cm

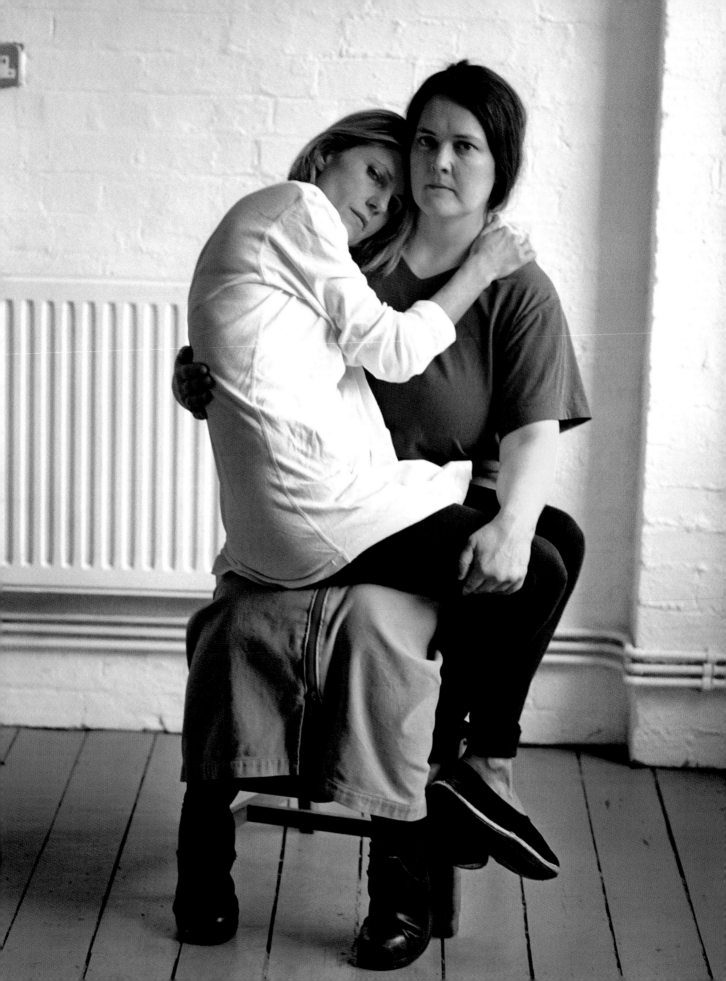

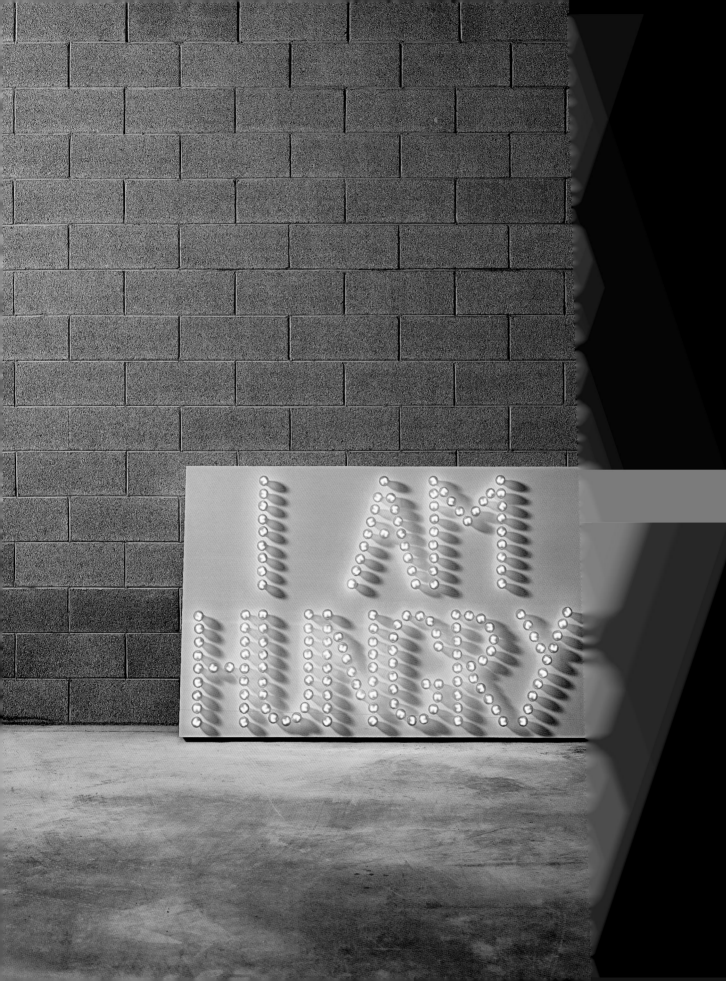

Alone and Together
by Alex Farquharson

The objects making the sculpture are arranged in a strict rectangular format, measuring around six and a half by four meters, about the dimensions of a typical Victorian front room. Everything is laid out neatly, like a bedroom quilt. Most of it reaches no more than knee height, except for two coat stands and two free-standing lamps, which in this streamlined situation take on quiet anthropomorphic presences, watching over the array of cushions, wooden palettes, and stuffed bin bags, like two pairs of stiff sentinels.

Although the assemblage is arranged as formally as a De Stijl painting, it is infused with a sense of human presence; specifically, the presence of the objects' implied owner, who seems to have been unexpectedly called away (the two seventies lamps are left on, the two antique fans survey the scene squeakily, and a video is running on the television set).

This sense of an absent presence is brought home by an empty bird cage, the life that it would usually hold having been substituted for a soundtrack of crystal-clear birdsong that rings out at intervals of several minutes from the television's speakers.

The footage on the television is not of birds, however, but of a golden Labrador puppy. The dog's realm is an ordinary domestic one, and what one takes to be an artist's studio, but for the dog her environment is a fun palace. The camera is left running for minutes at a time, observing this ebullient, insouciant life force with affection—mixed with a little envy perhaps.

The video has a strange, shifting relationship with the rest of the sculpture. The object it appears on—the old television set—belongs to the same order of things as the cushions,

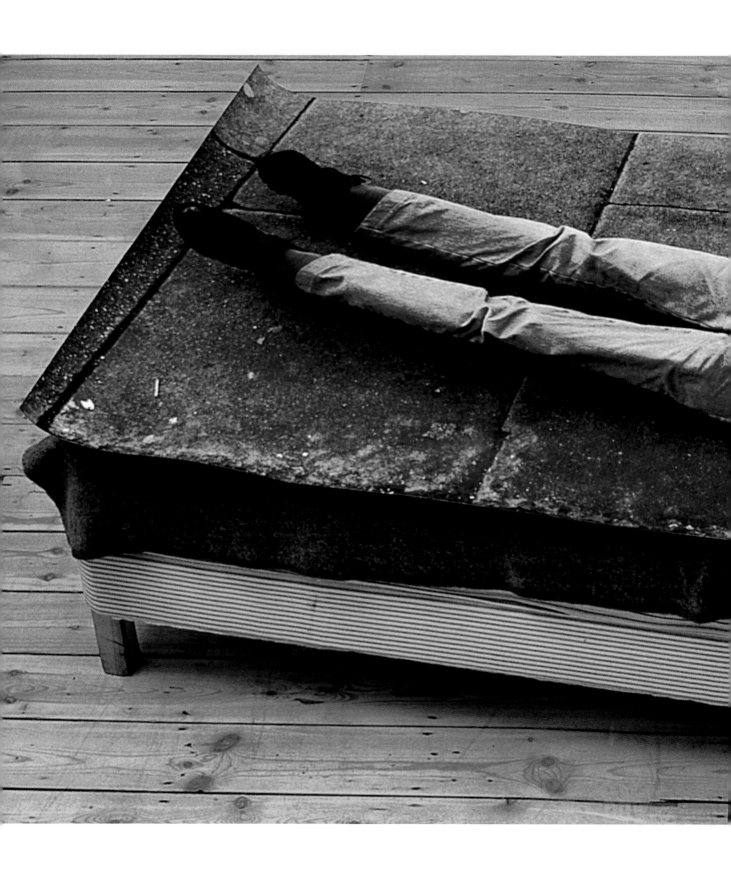

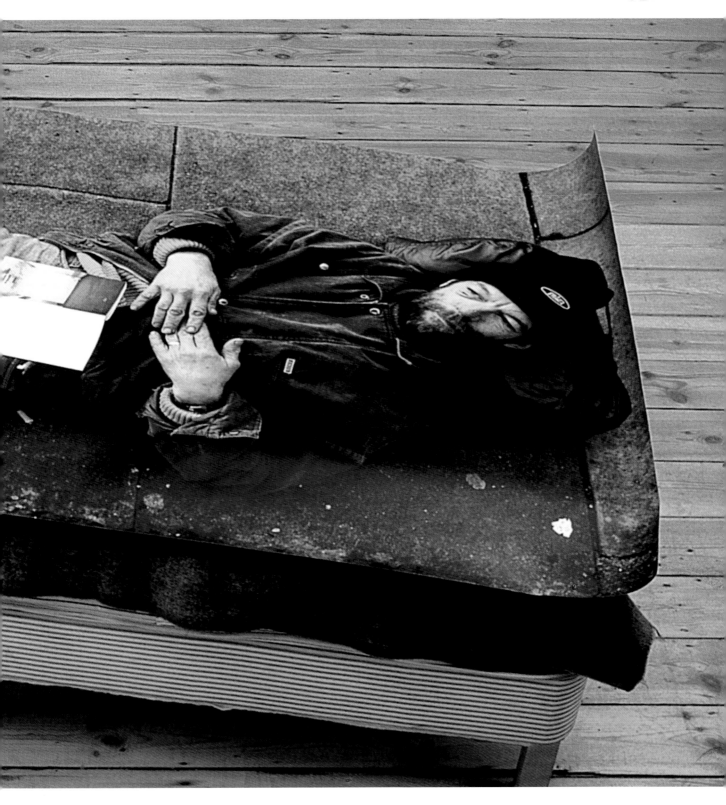

Garry, 2000
bed, photograph, book
190x90x40 cm

crates, coat stands, and potted herb plants, while what is depicted on its screen is flat and mediated by representational technology (a video camera). And yet, the kineticism and domesticity the video depicts, and its semblance of real time, echoes what is going on in the assemblage, so much so that the video and ready-made elements form a kind of continuum: the puppy looks set, at a moment, to cross the representational divide, enter the piece's empty wooden fruit crates, roll around its many cushions, and take on the exploratory role played by our eyes.

The virtual puppy, for its part, makes the objects around it appear less physical and more sign-like. The many doublings of objects—the lamps, the fans, the coat stands, and so on—also contribute to this sense. "Things in pairs," Annie Ratti observes, "stop being themselves." Together they become more abstract, on one level, while on another they give rise to new narratives they wouldn't evoke in the singular: subjectivities are traded for multiplicities.

Urban Landscape, Early Morning, in Autumn, the piece's title, contradicts our sense that we are in an interior. What can the word "landscape" imply about domesticity? Can we speak of an exteriorized domesticity—the temporary dwellings of nomads, for instance? Can we conceive of the concepts of "landscape," "city," "domesticity," "interior," and "exterior" as interchangeable in any way, as one and the same thing? Perhaps, the black sacks and the way the cushions, crates, and palettes are stacked call to mind Mediterranean markets or North African bazaars, sites at which the "indoors" opens onto "outdoors"; locations where signs of domesticity are exchanged and dispersed; places where the agricultural and artisanal produce of the landscape enters the city, before, perhaps, returning to it along new trajectories. The title, though, denies specificities, and resists such romantic lines of flight. We are simply in a city. It's left as generic as that. After all, what market sells bags of fall leaves?

The title does, though, locate us specifically in time, not once, but twice—we're offered a time of day and a particular sea-

son—which evokes an impressionistic, phenomenological sense of place, subject to shifts in light and weather, rather than one defined by material and topography. But how may a landscape be signified through an arrangement of domestic objects? At what point does text (the title) meet image (the sculpture)? Helpfully, there are a few objects that perform along the landscape/domesticity divide, such as the potted herbs and the bagged leaves. They seem to permit us to think of the large, flat, silk cushions as both luxurious cushions and verdant plains, and allow us to consider the antique fans' wheezy breeze as both a small indoor circulation of air and a transcontinental weather system.

This suggestion of a unified landscape, however, fast fades, as we recognize, again, the piece's joins, its strict geometry, its numerous plateaux. The cushion covers, themselves, refer to different geographies: some African, others Indian, Chinese, or Peruvian—each one a different "space-time" (as Deleuze and Guattari would have it), held together by a rudimentary substratum of palettes and containers, objects whose function is to move other objects around.

Garry and *I Am Hungry*—a portrait and a text piece—address homelessness and itinerancy more specifically. They are also urban landscapes in that they reflect familiar signs in cities (London especially). *Garry* is a life-size photograph of a homeless person positioned horizontally (like an actual landscape rather than landscape painting). It has a certain serenity, perhaps because the position Garry assumes, and the form of the work, is reminiscent of the life-size memorial figures of medieval knights carved into large slabs of stone in the floors of old churches. The height of the piece is similar to the height the real "Garry" would reach in the position he's lying in, but in the art work the height is provided by a mattress the exact dimensions of the photograph. This, in a sense, makes the representation more real, occupying not only our own space, but something like the space "Garry" would assume on the pavement. More significantly, on the level of feeling, the mattress represents a symbolic gift from the artist to "Garry"—a simple

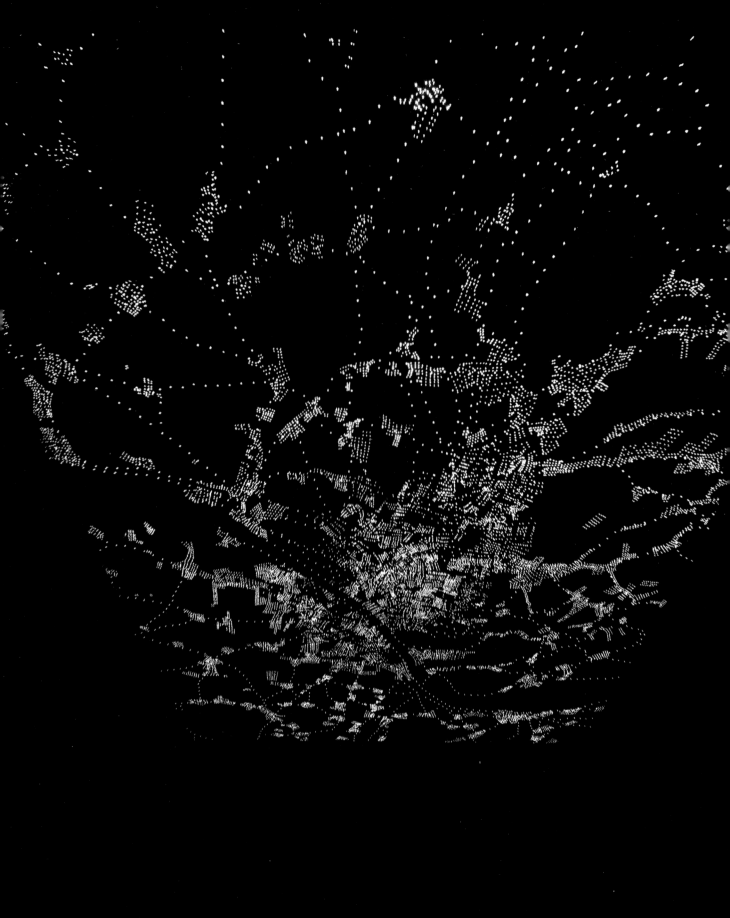

Left: Pianta di Vienna (Map
of Vienna), 1996
fabric, optic fiber, neon
350x550x480 cm

Tre coni (Three Cones), 1996
metal cones, video
three elements, 96x78x78 cm

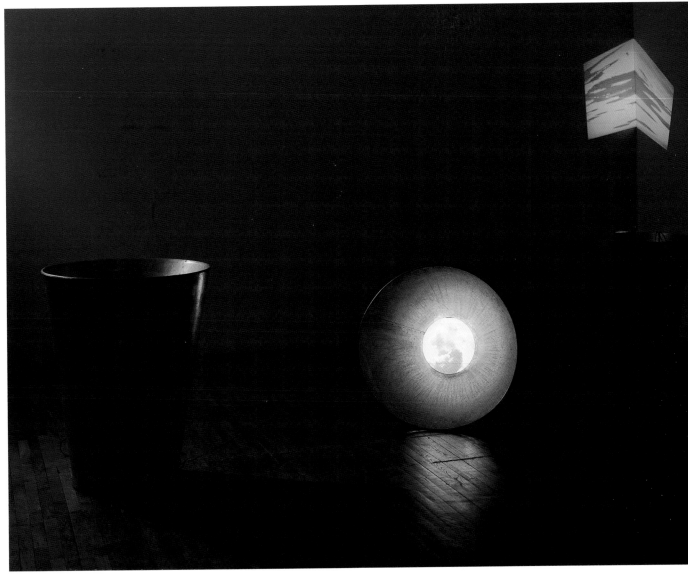

item that would bring comfort and dignity to the life of an-
other, as might the book on the work of contemporary artists
Dominique Gonzalez-Foerster and Eva Marisaldi that sits open
on the photograph, just below "Garry's" hands. Garry is por-
traiture, it is political, and it is also self-reflexive. Above all, and
embracing these other facets, it is an act of identification, the
artist and "Garry" both being located at some remove from the
everyday functioning of society.

Londoners are accustomed to seeing the sentence "I am hun-
gry" written on cardboard and held in the hands of the home-

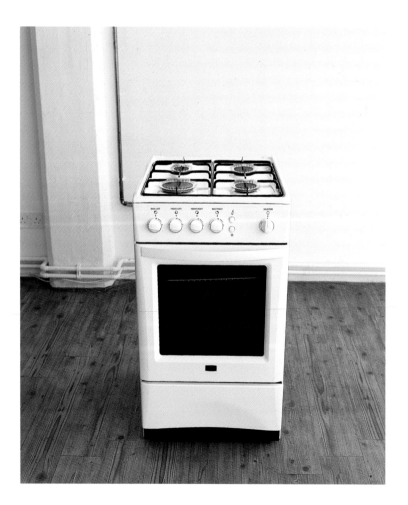

Burning, 2005
gas stove
51x70x102 cm

less. We're not familiar with those same words written in white lights, in the manner of "The Ritz" sign in Piccadilly. Read in this form, its meaning opens up. We begin to question what hunger is, and who this "I" might be referring to: is it "Garry"? The collective voice of the homeless? The artist? Ourselves? Whether relating to biological, emotional, or existential needs, the piece is performative, no less so than Annie Ratti's many functioning objects that invite the participation of viewers. As an act, rather than a description, what it is really saying is "I am communicating with you" and "I want to communicate with you," itself a form of hunger: the hunger that drives artistic expression.

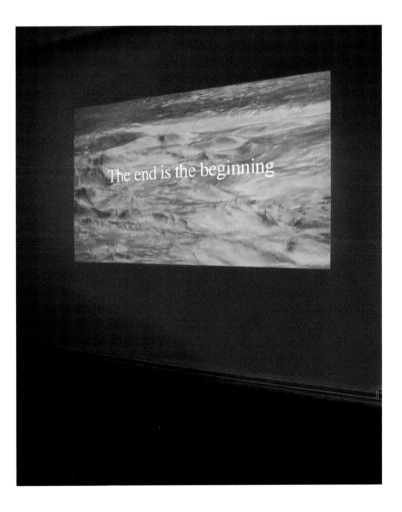

The End Is the Beginning, 2005
video projection
dimensions variable

Conversation between
Cesare Pietroiusti and Annie Ratti

Cesare Pietroiusti: To begin our conversation, could you tell us something about the work you intend to do for the White Box show? Seeing that the show is two months away, I must confess that I am curious to know if you have decided everything.

Annie Ratti: The project for White Box is born from the particular architectural nature of the space, and it is an installation that adapts to the place, which in turn has to adapt to the work. Operating on space has always been a more or less explicit feature of my artistic practice.

So in this space, I decided to invert the situation, making the floor of the gallery uncrossable by immersing it under water, and transforming the horizontal cement structure that runs across the space, and which is not normally accessible, into a walkway. From here visitors will be able to see the gallery space reflected and duplicated on the surface of the water. But the walkway will also be a place in itself where they can see a video projected on the wall in front of them, and other images projected on the other walls around them and reflected in the water.

The video images will speak of 'disappearance,' understood as a removal and as a possible reappearance somewhere else.

This is a subject that I feel close to, and with the loss of my sister I found myself engaging with it spontaneously.

The idea from which it originated and that preceded it involved immersing myself in the role of an outsider, a rather voyeuristic outsider, in order to represent a kind of testimony to the urban and social complexity of this city, using short video projections presented as little 'windows.'

Then things changed, and there was an urgent need to work on presence and absence, and so the last part of the work, the images with which the concept is expressed, have not yet taken on a definitive form. But, as always, everything will be sorted out in the end, the day before!

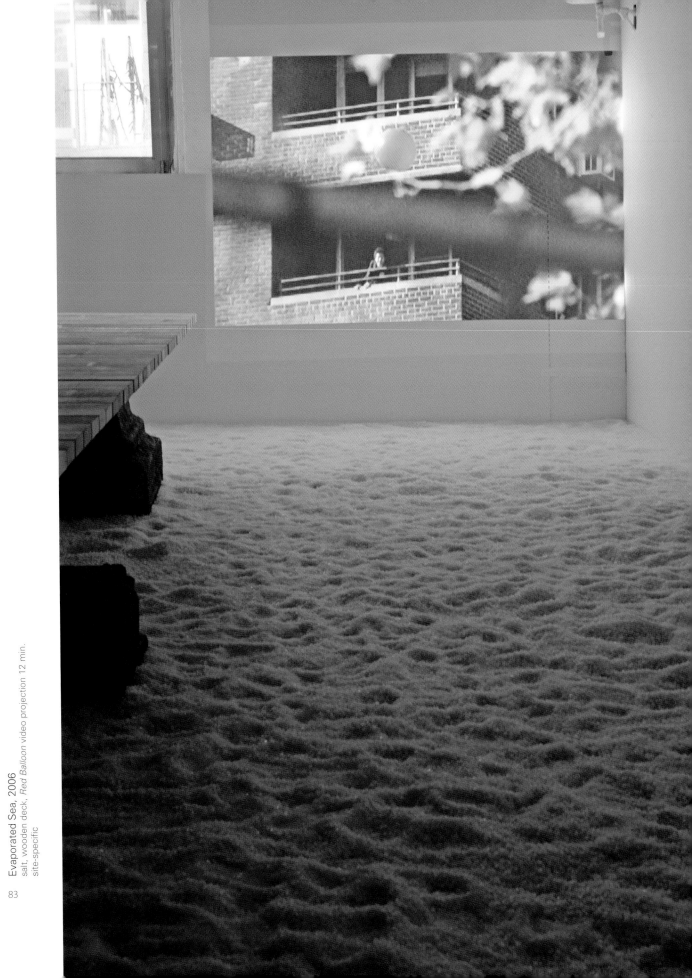

Evaporated Sea, 2006
salt, wooden deck, *Red Balloon* video projection 12 min.
site-specific

83

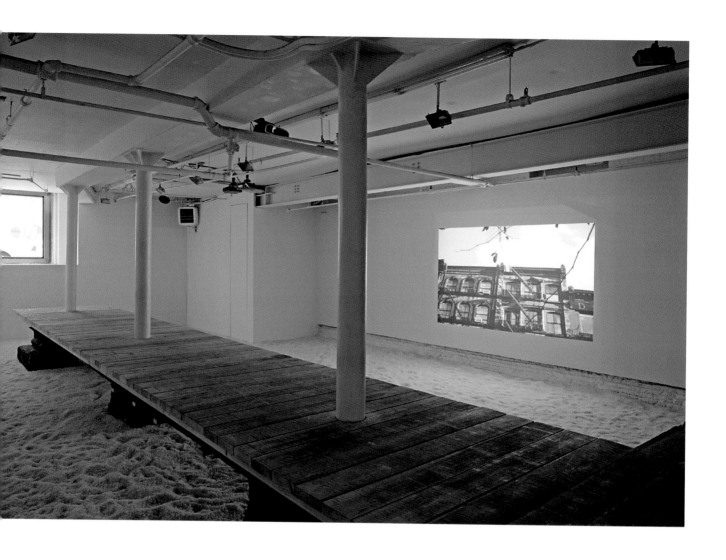

Evaporated Sea, 2006
salt, wooden deck, *Red Balloon* video
projection 12 min.
site-specific

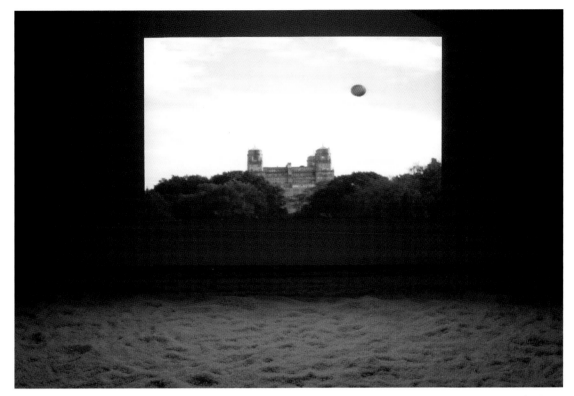

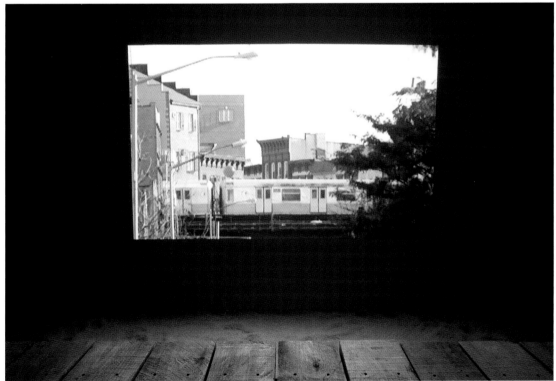

Red Balloon, 2006
video 12 min.,
produced with Christopher Walters

CP: I think it is interesting to emphasize this sensation of uncertainty. In an artist's work, it is not normally apparent—or there is only an implicit awareness—that there may be a great deal of uncertainty about the direction that an investigation should take, about how a certain idea should be expressed, about the language to be used, about the importance that should be given to technique, and so on. I would say that the run-up to an exhibition is the time when those uncertainties become more evident. Among other things, I think that, even when something that you are working on involves you emotionally, there is fear connected with the possibility that these emotions may only be yours and that they may not interest other people.

I would say, therefore, that for an artist the time before the show is a time when the mental projection of the public 'appears' as an 'other' that has to occupy a place inside you, and you are never sure that the encounter with the 'other' will produce coherence, sense, and mutual understanding. Don't you agree?

But, in the case of the work that you are preparing for White Box, it seems that your point of reference is also the space itself, in the sense that you are working 'with' the space rather than "in" it. You are exploring its particular characteristics and its strangeness. And perhaps the projection of a video is the hardest part of the installation, in the sense that it is difficult to make a video acquire an 'instrumental' dimension in relation to the perception (or experience) of an exhibition space. What generally happens is the opposite.

Getting back to the central issue, I would also like to know if you agree that the device that you intend to construct—transforming the sort of cement wharf structure that runs through the gallery into footbridges in the middle of the water—is actually seeking to determine a mental and proprioceptive state of uncertainty in the observer?

AR: I am glad you emphasize the element of constant uncertainty that defines artistic practice, the point at which one selects something to be exhibited, the different levels of consciousness, and also the feeling of fear. In this respect, artistic practice obviously reflects life and the constant condition of uncertainty that envelops it. A condition with which I immediately associate the idea of fragility and vulnerability. An idea whose weight and fascination I feel. It is not so much a matter of opposing 'monumentality,' of presenting direct resistance to whatever threatens us, but I think that in the fragility of things, in what is tiny and ephemeral, in

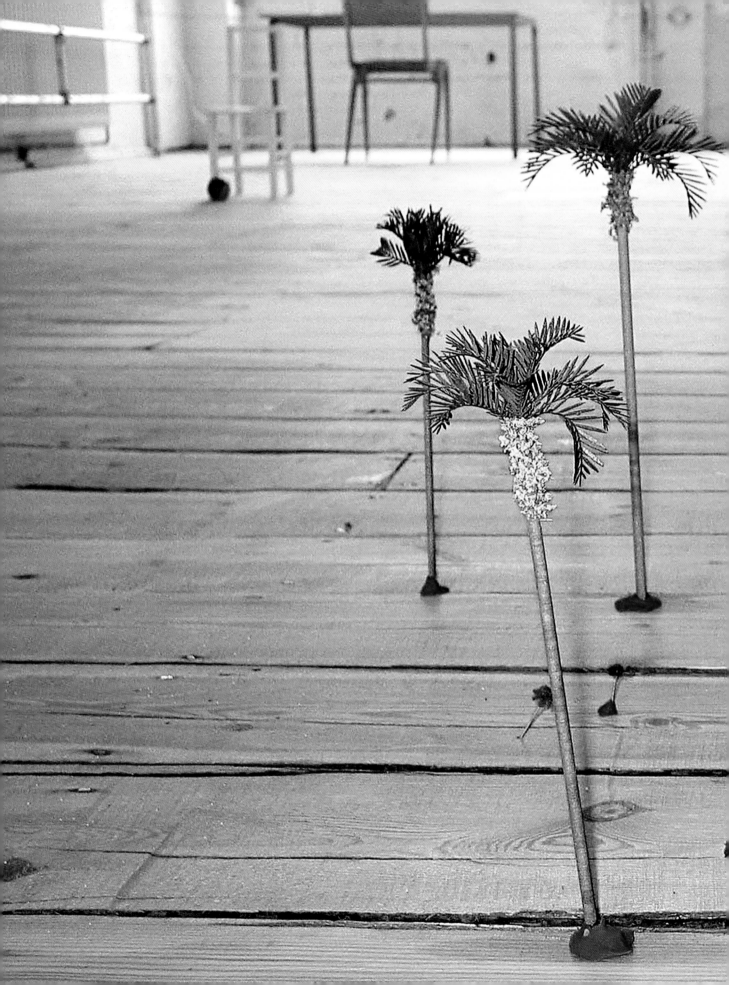

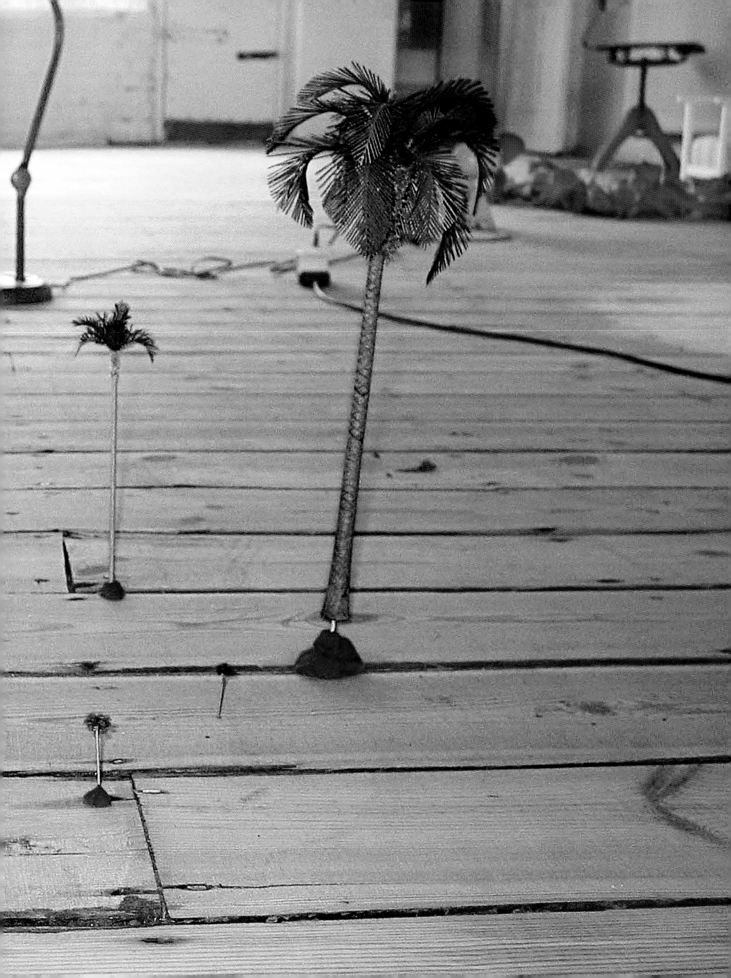

everything that exists and disappears, one can find an antidote, a poetics, a lightness that the forced imposition of self and will and all those great systems only finds with much difficulty or even systematically denies and overwhelms. I am really interested in that dimension, in recreating that atmosphere. One of the works that I am fondest of is an installation that has never left my studio: a heap of dust (or rather, various kinds of dust) and a collection of dry leaves with a fan that moves them and makes them shift and rustle; a lamp shining above some tiny palms planted on the floor, some writing resembling marks made with fingers on a patch of salt, and other similar interventions spread out on the floor and occupying space.

There are obviously different ways of working and of producing art. In my work, although it is always very constructed, I want to leave space for chance and interference, for things that happen along the way, and for the intervention of other people.

In Rome, for example, for the Volume! show, the subject of the enormous light box that obstructed the main entrance—a polystyrene box floating on the sea—was a reproduction of an image that suddenly materialized before me one morning. It was a mysterious, magical vision precisely because it was banal: I wondered how and why that rather battered greenish box had suddenly appeared there. Where had it come from? Why had it arrived there, in front of me?

Perhaps there is always the same discourse about fleeting appearance and disappearance, perhaps it is really an invisible thread that stitches many of my works together. But the fact is that the image of that box in the middle of the sea became the subject; it already contained within itself the light box for the show that I was preparing.

When one makes a work of art, one always has a point of departure, a pre-text, a basic idea, and then there is the point of arrival, the final landing place. But the paths that have to be pursued are many and undefined. And perhaps it is not so much a matter of finding the best path, the one that is surest and most direct, but of following the one that is closest to you, the one that you feel sticks closest to how you are at that precise moment along the way.

Perhaps it is that uncertainty that in turn leads to introspection. The act of hunting for yourself, or even finding yourself in conditions that are not pre-established, not being able to understand or make head or tail of things, produces an interesting energy. It makes you think and question everything you know, looking for solutions inside yourself or elsewhere. I am interested in that con-

Preceding page: General view of studio installation, 2002
Palms, lamp, salt, chairs, dead leaves, fan, ball

LAMPADA E POLVERE

recuperare lampada bianca e nera pangi e luona

Studio installation, 2002
drawings

LAMPADA A INFRAROSSI
(E POLVERE) / E PALME

LAVORO sul CALORE

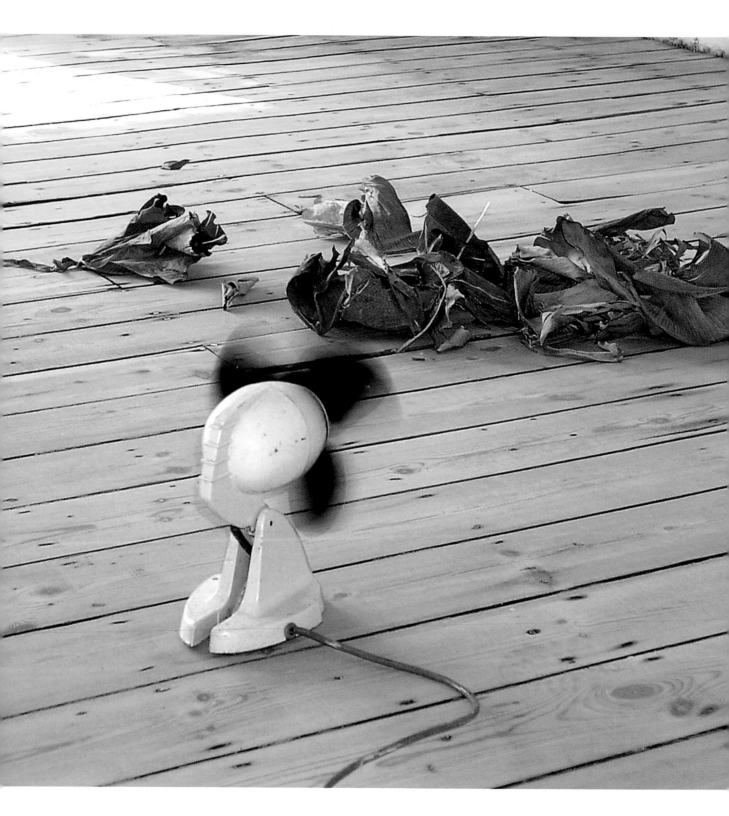

fusion, that disorientation: not knowing where you are or even if the direction that you have taken is the right one.

Someone once said that artists are like astronauts. It's true that when you know exactly where you are you never run risks, you cannot have uncertainties: you keep to what is safe, you say what you already know, and you know what you say. And you don't try to discover or suggest something that you don't already know.

The time before the show, as you say, is a time when your own way of seeing tries to identify with the way that others see. Reality is not inside you or me, but *between* you and me. And the work comes into being in that intermediate space, through the eyes of visitors attributing a meaning to it that does not belong entirely either to it or to them. That is how the work is transformed and transforms.

A work of art, visibly or invisibly, always transforms space with its presence. It alters space in the same way that a room can change when it is empty or when there is the presence of someone there: the energy and the perception of space are different.

My intervention at White Box uses the particular potentials and incongruity of that space.

It is an "instrumental" operation that exploits the space because it aims to put the visitors in a particular state, while at the same time it completes the exhibition space. In a way, inviting the visitors to walk on a footbridge means putting them on a stage, making them part of the stage setting of the work, and thus part of the work itself. But the walkway is also surrounded by water and has no protective barriers, and that places the visitors in an unusual state, perhaps of uncertainty and certainly of suspense. It makes them wonder where they are and why they are there, and what it is that they are taking part in.

Beyond the water, on the other side, on the other bank, you can see projections on the wall of a series of images that recall the constant possibility of disappearing, and they also suggest the beauty and enchantment of the world in which we become lost or go astray. Basically, the subject of the projection, disappearance, is the point of departure and arrival for this work.

CP: I feel that the dimension of uncertainty, giving shape to an attempt at existence that does not follow the logic of will and determination, of fixed knowledge that is affirmed rather than being discovered or challenged, is a response to a need. The need not to feel crushed by the production logic of economic and technological growth.

The 'fear' of machines was already among the apprehensions

View of studio installation, 2002
fan, dead leaves

underlying the industrial revolution, and people sensed that in nature or revolution there was salvation from falling into the mechanisms of 'modern times' and inevitable exploitation. I think that for a possibility of humanistic redemption it is no longer sufficient to seek refuge in nature, clearly devastated by a tourist approach that tends to prevail over any other experience of place, or in the comfort of an ideology of which one only senses a mystifying potential. It is not clear to me where that redemption can be found, but I think some hypotheses can be made. Giving value to the concept of 'inverse growth'; thinking of forgiveness and renunciation as political categories; paying heed to thoughts that seem useless and accepting deviations from one's own plans and intentions; not concealing subjective unease and suffering, but working on them collectively; eliminating the aura of the importance attributed to 'accomplishments' and specialization and giving value to the dimension of waiting. Properly considered, these attitudes seem to me to be a kind of spiritual exercise. Don't you think there is an increasing sensation that artistic exploration is one of the most credible paths for the practice of these 'exercises'? And that therefore artists are now faced with a task that earlier corresponded to philosophers, and then to politicians, and most recently to scientists?

I certainly agree that any work of art transforms the space that houses it. But, thinking particularly of a context like Chelsea, I feel there is (still) a very strong tendency to consider the exhibition space as neutral and 'aseptic,' precisely in the sense of a place that does not contaminate and is not contaminated by works of art. I think that the 'gallery' corresponds, as always, to a logic of 'separation.' The work exhibited becomes separate from the artist who made it and from the visitors who look at it, and also from the space that houses it. So much so that, with the act of selling, which sanctions a kind of definitive separation of rights, it can simply be removed. In this respect, White Box is an obvious exception, and a curious one; and I think that your project emphasizes this exception.

AR: Yes, everything starts with the need to recognize or rediscover a dimension of fragility, of exposure to uncertainty as a basis for human community, in contrast to the growing pressures of a society that would like us all to be perfect and perfectly sure and convinced, in the sense of being invulnerable and also of being dominated by certainties. This may seem a restatement of weak thinking. It is un-

doubtedly the antithesis of trivially 'Nietzschean,' superego thinking: eschewing any desire for power, it utters an elegy of weakness, of emotional fragility, of the sensitivity that we share and that defines us as human beings rather than clones, machines, or heroes. Let's be clear that it is not a question of accepting evil or making some kind of pretence. On the contrary, it means making unsureness a *positive* element, precisely because it is common: affirming and acclaiming the fragility and precariousness of the paths upon which we move, the relativity of the things in which we believe. It means, for example, if we go back to the idea of disappearance, thinking of humanity as something that is constantly destined to disappear, and thus finding the only possibility of stopping the deadly machine that is only concerned with resolving immediate requirements to the detriment of the future.

Art has always maintained, or at least has tried to maintain, a particular detachment, or perhaps a different, non-explicit adherence, in the confrontation of reality, of 'society,' and this has enabled it not to be linked to the system, not to be its direct reflection. Its non-immediacy is what has made it immediate; its non-utility has made it useful. Perhaps the very fact of not having a precise function, the particular 'autonomy' that it has, may indicate possible paths to be explored, buried realities to be rediscovered.

I ask myself and you whether, as artists, we are aware of this dimension, and therefore whether we want to accept this undertaking. But above all I ask myself and you whether it is not precisely this 'non-function' that defines art and enables it to exist in the state in which it is, or should be. Once we give it a precise function or status, art ultimately loses that quality, that (non-)usefulness, don't you agree?

I think that what we have most in common in our artistic practice is precisely the fact that we have tried to explore alternative paths where the work of art is not immediately identified with the aesthetic, economic consumer object, where it does not fix reality, but instead produces different forms of thought, energy, and life, situations in which the way of thinking is itself reflected and offered for discussion.

Producing art is, first and foremost, producing thought: it is reflecting and seeking truth beyond what is evident. That is precisely why I have always found it more natural to interact with spaces whose identity is not directly connected with the 'objective' laws of the market: spaces run by artists or by people whose understanding of art is closer to mine.

Here the discourse certainly needs to be taken further: with the art system becoming increasingly omnivorous and metabolizing

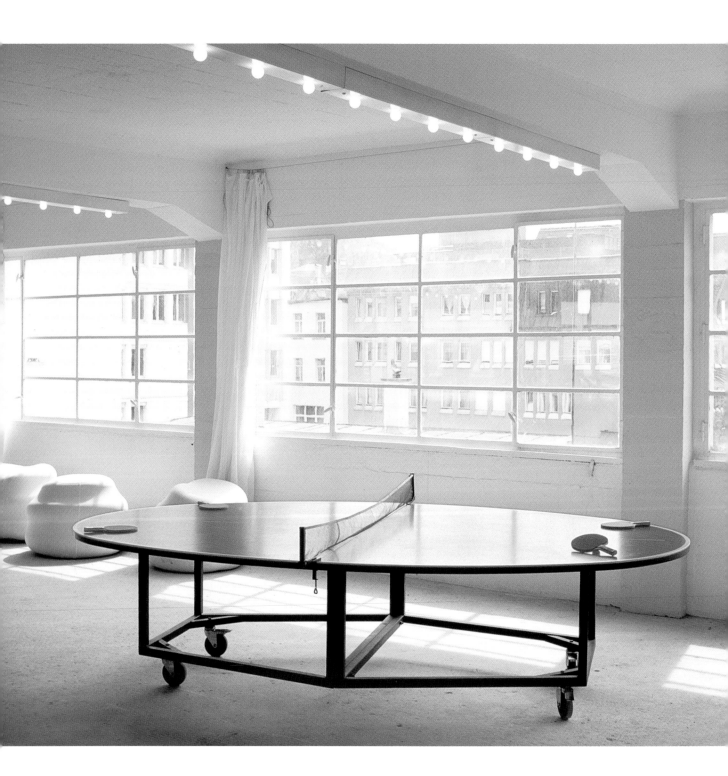

everything, it no longer seems to make sense to contrast a 'non-profit' space with a 'profit' space. But, above all, the most obvious thing is the unsuitability of exhibition spaces, regardless of whether they are public or private, in relation to the forms that art has taken and is taking. In this respect, art has definitely advanced, it has transformed itself, whereas all its containers, the museums and galleries, are lagging behind: they are not succeeding in altering their role, their idea of space, and so they cannot respond or correspond to the current demands of art.

Art now is no longer content with itself, with its supposed certainties, its parameters, its constant self-quotations. It is escaping from the schemes and places in which it has been confined, becoming other and devoting itself to otherness, occupying different, unusual spaces.

The last Documenta gave a good idea of the direction in which we are heading. The need to give space to collective experience, to devote oneself to investigation and teaching, to abandon all discourse about the artist's identity or market needs, and therefore to expand and escape to other territories, taking forms that are completely different than what is still considered art.

The discourse is certainly becoming very complex, but it would be worth trying to produce a more consistent collective reflection.

Meanwhile, as we wait for the invention of a different way of thinking about and of housing art, I cannot deny that there is a different air that one can breathe in all the alternative, non-conventional, and non-conventionalized spaces, which is where I feel much more at ease.

CP: Sometimes, when I look at your work or listen to you talking (for example, about the floating polystyrene box), a 'childlike' way of thinking comes to mind, in the sense that a child is someone whose attention grasps visions and voices that escape the adult. Agamben says: 'One can . . . see playing as a strategy for inventing new uses. In this sense, children are the great preservers of humanity and at the same time great agents of revolution; they preserve forgotten things and they also transform them, making them move from a separate sphere (sacred or economic) to a new use.' How do you manage your childlike thinking, if I may put it like that?

Ping-Pong, 1997
plywood, varnish, metal structure, castors, net, bats, ping-pong balls
75x196x304 cm

AR: Our 'child self' is what keeps us alive, enabling us to see things that we would otherwise not see. And also the possibility of seeing the world upside-down, inverting and transforming things when necessary. It allows us not to lose the amazing, playful sense of existence, the levity imbued with wisdom—precisely because it is a little crazy—with which we can face the darkness.

And so my child self is very often my guide: it tells me where to go, which path to take, which one not to take. It is my freedom of thought, my constant curiosity as I explore the world that I do not know. It is also through my child self that I look at the world and approach it and probably create my works.

CP: I think that once again it is necessary to announce that the emperor has no clothes—not just the emperor of an external, falsely cordial power, but also the inner emperor of our preoccupations, convictions, and ideologies. By trying to do the opposite of what might be expected, or at least introducing diversions into our strategies, I think it always teaches us a great deal about preconceptions connected with effectiveness, success, and even happiness. You ask me whether we, as artists, can be aware of the 'exercises' of which we were speaking and, ultimately, whether we want to be aware. I think awareness is important, but probably it is not a question of awareness attached to a 'force'—for example, a 'conviction,' but rather to a state of weakness—what I would call a need to respond to a personal inadequacy, a 'defect.' In my view, inventiveness always comes much more from that than from intention.

I was looking at your *Biblioteca*: isn't it about a desire to combine the knowledge that comes from books, which we consider valuable, with a sensation of warmth, a tactile need for contact? And isn't there also something similar in *Ping-Pong*, *Letto volante*, etc.?

How much of the artist's work, your work, comes from a lack, a 'defect'?

AR: I am reminded of the relationship between an oyster and its pearl.

The oyster is irritated by a grain of sand that penetrates into its habitat, working its way in between the shell and its delicate body. And so it produces saliva to protect itself from the hardness of the sand, slowly enveloping and transforming the grain of sand into a magnificent pearl.

In us, there is also, probably, an original deprivation, or a defect, if you like, which Freud called *le manqué*. And it is the desire to

fill that emptiness, to respond to that inadequacy, that drives us towards art. Obviously, it is not all as clear and simple as that. The work we do with the grain of sand is just as complex: it is a constant process of reworking or sublimation of that defect, of one's own deficiencies.

It is probably the uneasiness attached to being in the world and the perplexity at a system that I still think of as unjust that has led me to choose this path. But it is also an inability to express myself by other means, an awareness of a defect, a deficiency, combined with a desire not to become part of a system that was not right for me then and in which, increasingly and with growing justification, I still do not see myself as belonging to now.

It is true that the free-standing library resembling a soft cuddly toy, containing books that have been and still are important for me, represents an ideal of life and partly makes up for the severe, strict environment in which I grew up, a mixture of coldness and asepsis. It is also true that the playful dimension of my work tries to find the note of levity that I have always attempted to maintain, in spite of everything.

Perhaps, it also has to do with our role as artists, with the 'spiritual exercises' that we were speaking of earlier. I think the most important thing is not to lose the sense of modesty, the awareness of the defect that marks us, the fragility that characterizes us, and instead to make it grow greater day by day.

CP: I often think of the self-other dialectic. In this time of religious fundamentalism and violent opposition greatly emphasized by the media, the ideology of identity and separation ('I am I, irreducibly different and separate from the other') expands as if in response to some kind of contagion; but the ideology of difference only seems to succeed in producing faltering hypotheses of 'tolerance' and acceptance of diversity. Don't you think the time has come to recognize that the 'other' forms an inevitable, constitutive part of the 'self'? That the very life of an identity is impossible without the presence of difference within it; that the oyster, if we go back to your splendid example, really lives only when it is 'irritated' by the grain of sand? And if we are inhabited by that 'other,' by urgings that belong to us but which we are not able to recognize fully, could it not be that art performs its poetic function precisely when it touches on those urgings and makes them quiver? I think that the problem of the work of art is not a question of saying the 'right' thing, but of probing into contradictions. I think that works of art that are only 'good and right' ultimately perform a concealment. The

concealment may possibly help to make a work of art coherent and comprehensible, but the result is the unavailability of the subtle and sometimes mysterious element of fellow feeling, of assonance with 'personal' realities, not wholly defined, that any poetic act activates and allows us to discover. Basically, I like to think that the causing-to-quiver that the work of art performs on the 'secret' cognitive and emotional articulations of those who come into contact with it is really a mechanism of liberation of ideas and feelings. I do not know whether it is a misfortune or a blessing, yet it seems to me that this liberating function of art is, quite simply, endless. And that it does not lead to any specific place.

AR: I agree. Art can never hide by saying 'the right thing.' Fragility, defects, grains of sand, but also absence and disappearance. There is the final scene in a film by Kiarostami (with a lovely title, *Life and Nothing More*, I think), in which we see a car zigzagging its way up a hill, and at the top of the hill two tiny figures, two people walking: perhaps one of them is the person that the film director has been looking for throughout the film (the young leading actor in his previous film, who he fears may have died as a result of a terrible earthquake). But he never finds out, because on the last bend the car slows down and comes to a halt; it has run out of gas, and it rolls back down the hill. That is what disappearance is. Not certainty, but the quivering of doubt. And perhaps that is the scene of the crime on which we work as artists. Something that lacks an ending, that lacks the certainty of a conclusion, of a specific place where everything finds an explanation and an end.
I am reminded of the image with which Michel Foucault concludes *The Order of Things*, speaking of disappearances . . . and sand: a drawing of a man's face on the sand erased by the lapping of the sea.

Rome, September 20, 2006

Post scriptum

Dear Cesare,
In the meantime, the exhibition opened, and to confirm what we were saying, the project has changed. Flooding the gallery as I initially wanted to ended up being too complicated. The sea has dried out, and instead of water, a layer of crystal white salt occupies the gallery floor. As often happens, technical difficulties transform the project into something different, something more delicate, like *Evaporated Sea*.

Willy il coyote (Wile E. Coyote), 1999
hole, cement bricks, glass
155x112x20 cm

100

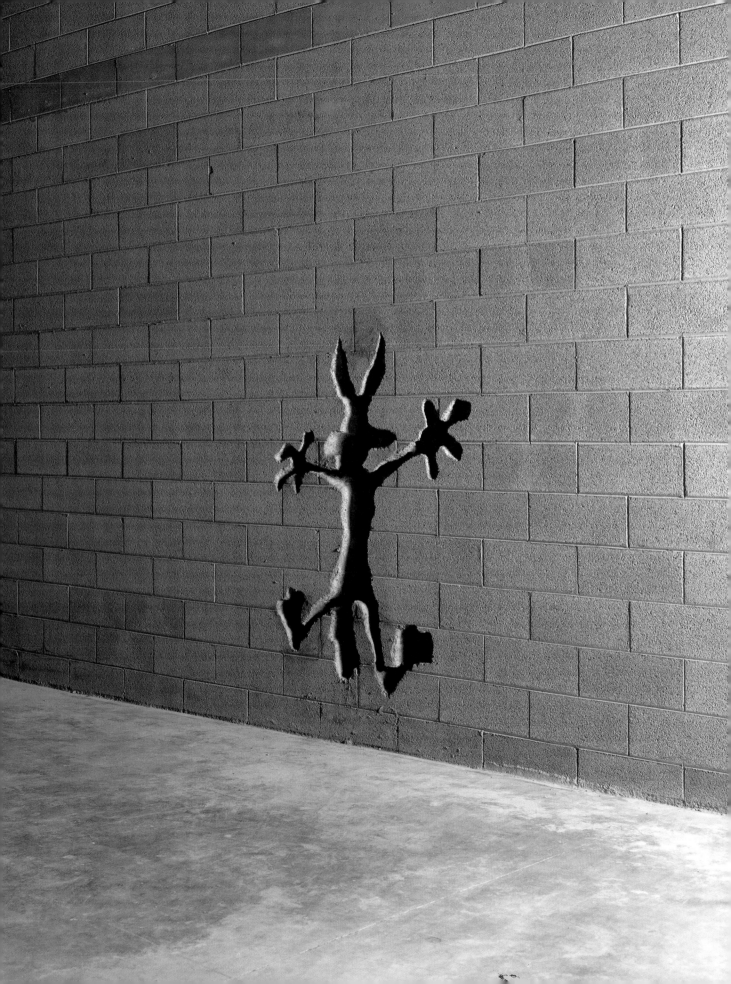

List of Works

Shadow, 1996
video projection, b/w, 4 min
200x250 cm
Espace d'Art Contemporain, Paris, 1996 (solo show)
pp. 7-8

Tre coni (Three Cones), 1996
metal cones, two videos, one video projection
three elements, 96x78x78 cm
Espace d'Art Contemporain, Paris, 1996 (solo show)
XII Quadriennale, Palazzo delle Esposizioni, Rome,
1996
p. 79

Pianta di Vienna (Map of Vienna), 1996
fabric, optic fiber, neon
350x550x480 cm
Oscar, Galleria La Nuova Pesa, Rome, 1997 (group show)
Am Horizont des Sehens, Austellungszentrum im
Heiligenkreuzerhof, Vienna, 1998 (group show)
p. 78

Biblioteca (Library), 1997
plywood, varnish, padding, fake fur, books, objects,
video tapes
four elements, 220x ø350 cm
Voralberger Kunstverein, Magasin 4, Bregenz, Austria,
1997 (solo show)
Ticosa Spazio del Moderno, Como, Italy, 1999 (solo show)
p. 17

Piste de Dance (Dance Floor), 1997
Installation, plywood, resin, metal
40x400 cm
Magazin 4, Bregenz
p. 45

Cabina (Cabin), 1997
metal, PVC, monitor, *You and Me* video (loop)
300x ø190 cm

Voralberger Kunstverein, Magasin 4, Bregenz, Austria,
1997 (solo show)
Fuori uso 97. Perché, Pescara, Italy, 1997 (group show)
p. 46

Letto volante (Flying Bed), 1997
PVC sheet, metal structure, foam rubber, fabric, steel
cables, technical ladder
80x180x140 cm
Officina Italia, Galleria d'Arte Moderna, Bologna, Italy,
1997 (group show)
Ticosa Spazio del Moderno, Como, Italy, 1999
(solo show)
p. 14

Ping-Pong, 1997
plywood, varnish, metal structure, castors, net, bats,
ping-pong balls
75x196x304 cm
Voralberger Kunstverein, Magazin 4, Bregenz, Austria,
1997 (solo show)
Officina Italia, Galleria d'Arte Moderna, Bologna, Italy,
1997 (group show)
Ticosa Spazio del Moderno, Como, Italy, 1999
(solo show)
p. 97

Six Pants, 1997
rubber cloth, metal structure, elastic string
six elements, 200x75 cm each
Ticosa Spazio del Moderno, Como, Italy, 1999 (solo
show)
Gallery Sejul, Seoul, 2004 (solo show)
p. 51

Soucoupe (Saucer), 1997
resin, wood, electrical, lights, motor, radio control,
polyurethane foam, musical accompaniment ("La valse
à Mille Temps") by Jacques Brel
60x ø160 cm
Performance at Solstizio d'Estate 2, Centro Civico per
l'Arte Contemporanea La Grancia, Serre di Rapolano,
Siena, Italy, 1997 (group show)
Ticosa Spazio del Moderno, Como, Italy, 1999 (solo

show), performance Lake Como, Italy
p. 13

Due artiste (Two Artists), 1998
cibachrome on paper, audio system, music by Geraldine Alles
280x185 cm
Am Horizont des Sehens, Austellungszentrum im Heiligenkreuzerhof, Vienna, Austria, 1998 (group show)
Dandy, Pio Monti, Rome, 1998 (group show)
Ticosa Spazio del Moderno, Como, Italy, 1999 (solo show)
La casa, il corpo, il cuore, Museum Moderner Kunst Stiftung Ludwig, Vienna, 1999 (group show)
…Du Aber Bist Der Baum (with Carla Accardi and Bruna Esposito), Monastero delle Lucrezie, Todi arte festival, Todi, Italy, 2003
p. 71

La Porta dei Sogni (Dream Door),
with Bruna Esposito, 1998
pillows, covers, string, lavender
360x80x120 cm
Indoor, Centro Civico per l'Arte Contemporanea La Grancia, Serre di Rapolano, Siena, Italy, 1998 (group show)
p. 52

This Is Not My Cup of Tea, 1998
resin, foam rubber, leatherette, lead, wooden frame, world map, engine, electric wire
95x90x180 cm
Am Horizont des Sehens, Austellungszentrum im Heiligenkreuzerhof, Vienna, 1998 (group show)
Ticosa Spazio del Moderno, Como, Italy, 1999 (solo show)
p. 55

Xilofono (Xylophone), 1998
iroko wood, foam rubber, straps, sticks, felt case
80x720x100 cm
Indoor, Centro Civico per l'Arte Contemporanea La Grancia, Serre di Rapolano, Siena, Italy, 1998 (group show)

Ticosa Spazio del Moderno, Como, Italy, 1999 (solo show)
Sound + Vision, a project by Janus, Axel Vervoordt Kanaal, Wijnegem, Antwerp, 2004 (group show)
pp. 38-39

I Am Hungry, 1999
plywood, white varnish, light bulbs, electrical component
114.5x178x20 cm
Ticosa Spazio del Moderno, Como, Italy, 1999 (solo show)
Urban Landscape, Early Morning, in Autumn, Italian Cultural Institute, London, 2003 (solo show)
p. 72

Fin de siècle (End of the Century), 1999
inkjet print on gauze, wooden frame, dirt, barley seeds, waterworks, PVC life belt
70x ø420 cm
Indoor, Musée d'Art Contemporain, Lyon, 1999 (group show)
Ticosa Spazio del Moderno, Como, Italy, 1999 (solo show)
p. 15

Land Man, 1999
inkjet print on paper
96.5x400 cm
La casa, il corpo, il cuore, Museum Moderner Kunst Stiftung Ludwig, Vienna, 1999 (group show)
Ticosa Spazio del Moderno, Como, Italy, 1999 (solo show)
Serendipiteit, Watou, Belgium, 1999 (group show)
Rendez-vous, Ars Aevi, Novi Hram Gallery, Sarajevo, 2001 (group show)
Gallery Sejul, Seoul, 2004 (solo show)
p. 42-43

Nido (Nest), 1999
polyurethane foam, blankets, cloth, felt, metal, sleeping bags, foam rubber, light bulbs, audio system, music
320x ø160 cm
In Situ, Torre San Severo, Orvieto, Italy, 1999 (group show)

Ticosa Spazio del Moderno, Como, Italy, 1999 (solo show)
p. 20, 21

Tête à Tête II (You and Me), 1999
wood, seats, leatherette
140x81x124 cm
Urban Landscape, Early Morning, in Autumn, Italian Cultural Institute, London, 2003 (solo show)
p. 68

Willy il coyote (Wile E. Coyote), 1999
hole, cement bricks, glass
155x112x20 cm
Ticosa Spazio del Moderno, Como, Italy, 1999 (solo show)
Site-specific
pp. 9, 101

Vuoti D'Acqua (Water Voids), 1999
light-box
128x176x15 cm
Ticosa Spazio del Moderno, Como, Italy, 1999 (solo show)
p. 8

Bird's House, 2000
plywood, lead
25x25x30 cm circa
Kunst in der Stadt 4, Kunsthaus Bregenz/Bregenzer Kunstverein, Bregenz, Austria, 2000 (group show)
p.18

Bird's Island, 2000
plywood
55x105x185 cm circa
Kunst in der Stadt 4, Kunsthaus Bregenz/Bregenzer Kunstverein, Bregenz, Austria, 2000 (group show)
p. 19

Bird's Table, 2000
plywood

90x60x185 cm circa
Kunst in der Stadt 4, Kunsthaus Bregenz/Bregenzer Kunstverein, Bregenz, Austria, 2000 (group show)
p. 18

Garry, 2000
bed, photography, book
190x90x40 cm
…Du Aber Bist Der Baum (with Carla Accardi and Bruna Esposito), Monastero delle Lucrezie, Todi arte festival, Todi, Italy, 2003
Urban Landscape, Early Morning, in Autumn, Italian Cultural Institute, London, 2003 (solo show)
Luoghi d'affezione, paesaggio-passaggio, Hôtel de Ville, Bruxelles, IKOB (Internationales Kunstzentrum Ostbelgien), Eupen, Belgium, 2003–2004, curated by Angelo Capasso (group show)
pp. 74-75

Spazio Affettivo (Affective Space), 2000
fiberglass, metal, cradle, video monitor
ø600 cm
A Casa di, Fondazione Pistoletto, Biella, Italy, 2000 (group show)
Gallery Sejul, Seoul, 2004 (second version ø1050 cm) (solo show)
p. 60

Pontile (Pier), 2001
wood, portable radio
405x70x48 cm
Adriatico, le due sponde, 52°Premio Michetti, MuMI – Museo Michetti, Francavilla al Mare, Palazzo San Domenico, Italy, 2001 (group show)
p. 57

Urban Landscape, Early Morning, in Autumn, 2001
pallets, cushions, crates, lamps, plants, fans, video
665x400 cm
Urban Landscape, Early Morning, in Autumn, Italian Cultural Institute, London, 2003 (solo show)
Settlements, Musée d'art Moderne, Saint-Étienne, 2004 (group show)
pp. 24-25, 26, 27

Apparizione (Appearance), 2003
Light box
180x128 cm
I Love You, Volume, Rome (solo show), *La crise économique, c'est fantastique, la décadence c'est la bonne ambiance*, Jousse Enterprize Gallery, Paris
p. 10

Homage to Korea, 2004
dirt, perspex, slide and security video monitors, found objects from North and South Korea
1100x500 cm
Gwangju Biennale, Gwangju, 2004 (group show)
pp. 28-29, 30-31

The End Is the Beginning, 2005
video projection
Dimensions variable
40 Days/40 Nights, Redux, London
p. 81

Burning, 2005
gas stove
51x70x102 cm
40 Days/40 Nights, Redux, London
p. 80

Where I Want To Be, 2006
fiberglass, rubber, 4 CDs, 4 CD players, game table
75x75x75 cm
Manifesto Bianco, Diapason Gallery, New York
p. 61

Billboards: The Limits of My Language Are the Limits of My World, 2006
six color prints on six billboards
350x350 cm
Kunsthaus Bregenz, Austria
pp. 62, 63, 64, 65, 66, 67

Evaporated Sea, 2006
Salt, wooden deck, video projection 12 min.,

site-specific
Evaporated Sea exhibition, White Box, New York
pp. 30-31, 32-33, 34-35, 36-37, 83, 84, 88-89

Red Balloon, 2006
Video (produced with Christopher Walters)
Evaporated Sea exhibition, White Box, New York
p. 85

Biography

Annie Ratti lives and works in London and New York.

Solo Exhibitions

2006	*Evaporated Sea*, White Box, New York
	Die Grenzen meiner Sprache bedeuten die Grenzen meiner Welt, Billoards Kunsthaus Bregenz, Austria
2005	*40 Days/40 Nights: A Collaboration of Annie Ratti and Peter Lewis*, Redux Project, London
2004	Sejul Gallery, Seoul
	La lampada di Aladino, Bambin Gesù Hospital, Rome, public work on permanent display
2003	*Urban Landscape, Early Morning, in Autumn*, Italian Cultural Institute, London
2002	*I Love You*, Volume, Rome
1999	*Annie Ratti*, Ticosa Spazio del Moderno, Como, Italy
1997	Voralberger Kunstverein Magazin 4, Bregenz, Austria
1996	Espace d'Art Contemporain, Paris
1995	Via Farini, Milan
1994	Galleria Nova, Rome
1993	*Il gatto e la volpe* (with Getulio Alviani), Monti Associazione Culturale, Rome Roma Arte, Rome
1992	Galleria Nova, Turin, Italy
	Associazione Culturale Per Mari e Monti, Macerata, Italy
1991	*Praticabili-Impraticabili*, Studio Spaggiari, Milan
1990	Galleria Nova, Rome
	Casa Veneta, Muggia, Trieste, Italy
1989	*I quaderni di San Sebastiano* (with Carla Accardi), Oratorio di San Sebastiano, Forlì, Italy
1988	*Il mio bosco*, Studio Bocchi, Rome
1986	Espace "Le Bateau Lavoir," Paris
1984	The Clock Tower, in collaboration with Sofia Nicoletti, New York
1983	*Fashion Moda*, South Bronx, New York

Selected Group Exhibitions

2006	*Manifesto bianco*, Diapason, New York
	D'ombra, Palazzo delle Papesse, Siena, Italy / MAN, Nuoro, Italy (2007)
	Dual Realities, 4th Seoul International Media Art Biennale, Media City Seoul, Seoul
2004	*Sound+Vision*, Wijnegem, Belgium
	RAM, Sound Art Museum, Rome
	Settlements, Musée d'Art Moderne, Saint-Étienne
	A Grain of Dust, a Drop of Water, Gwangju Biennale, Gwangju, South Korea
	Ateliers D'artistes à L'hôpital, Paris
2003–2004	*Luoghi d'affezione (Paesaggio-Passaggio)*, Musée de Ville, Bruxelles, IKOB, Eupen, Belgium
2003	*La crise économique, c'est fantastique, la décadence c'est la bonne ambiance*, Jousse Enterprise Gallery, Paris
2002	*Playgrounds & Toys for Refugee Children*, Museo Cantonale d'Arte, Lugano, Switzerland
2001	VI Biennale di scultura SPSAS-Visarte, Cureglia, Switzerland
	Adriatico, le due sponde, 52°Premio Michetti, MuMI – Museo Michetti, Francavilla al Mare, Palazzo San Domenico, Italy
	Obsorge, Kunsthaus Zug, Zug, Switzerland
	Rendez-vous, Ars Aevi, Galleria Novi Hram, Sarajevo
	Indoor, Stedelijk Museum voor Actuele Kunst, Ghent
2000–2001	*Playgrounds & Toys for Refugee Children,* Museo Hendrik Christian Andersen, Rome
2000	*Welcome*, Palazzo delle Esposizioni, Rome
	A Casa di, Fondazione Pistoletto, Biella, Italy
	Kunst in der Stadt, Kunstverein Kunsthalle Bregenz, Austria
1999–2000	*From Where to Here, Art from London,*

	Konsthallen, Göteborg	
1999	*Alle soglie del Duemila*, *Arte in Italia negli anni '90*, Palazzo Crepadona, Belluno-Galleria Civica, Cortina d'Ampezzo, Italy	
	La casa, il corpo, il cuore, Museum Moderner Kunst Stiftung Ludwig, Vienna	
	Indoor, Musée d'Art Contemporain, Lyon	
	Arena 1999, ARENArte Montagnana, Montagnana, Italy	
1998	*Indoor*, Serre di Rapolano, Centro Civico La Grancia, Siena, Italy	
	Am Horizont des Sehens, Ausstellunszentrum im Heiligenkreuzerhof, Vienna	
	Dandy, Pio Monti, Rome	
	Riparte, Sheraton Hotel, Rome ("Progetti da camera" by Pio Monti, Rome)	
1997	*Oscar*, Galleria La Nuova Pesa, Rome	
	Fausta, Associazione Culturale Per Mari e Monti, Macerata	
	Officina Italia, Galleria d'Arte Moderna, Bologna, Italy	
	Fuori Uso '97 – Perché, Pescara, Italy	
1996	*Le Mille e una Volta*, Galleria d'Arte Moderna e Contemporanea, Repubblica di San Marino	
	XII Quadriennale, Italia 1950-1990, Ultime generazioni, Palazzo delle Esposizioni, Rome	
1995	21st International Biennial of Graphic Art, Lubljiana	
	FVROR POPVLI – FORVM POPVLI, Monti Associazione culturale, Rome	
	Cose dell'Altro Mondo, Trevi Flash Art Museum, Trevi, Italy	
1994	*Ante Rem Post Rem*, Ex Convento di San Domenico, Spoleto, Italy (on the occasion of the XXXVII Festival dei Due Mondi)	
	VHS, Palazzina Liberty, Milan	
	Ars Lux, various venues in Italy	
1993	*Arte in Classe*, Scuola Elementare Giosué Carducci, Rome	
	Rentrée, Ancona, Italy	

	Omaggio ad Angelica Kauffmam, Museo Vaduz, Vaduz Lichtenstein
	Trasparenze dell'Arte sulla via della carta. Rassegna Internazionale della cultura Italiana, Centro Culturale Italiano, Beijing
1992	*Roma - Mosca Artisti d'oggi a confronto*, Galleria Sprovieri, Rome
1991	*Arie*, Fonti di Clitunno, Spoleto, Italy (on the occasion of the XXXIV Festival dei Due Mondi, Spoleto)
	Triennale della Piccola Scultura e del Bronzetto, Palazzo della Ragione, Padua, Italy
	Anni '90, Galleria d'Arte Moderna, Bologna, Italy
1990	*IV Biennale Donna. Il gioco delle parti*, Palazzo dei Diamanti, Ferrara, Italy
	Giovani Artisti a Roma III. Venticinque giovani artisti al Palazzo delle Esposizioni, Palazzo delle Esposizioni, Rome
1989	*Se una sera d'autunno...*, Galleria Dell'Oca, Rome
	Arca, Castello di Volpaia, Radda in Chianti, Siena, Italy
	Di terra in terra, Palazzo Borbonico, Caltagirone, Catania, Italy
1988	*4x2 Duetti d'artista*, Studio Ghiglione, Genoa
	Il cielo e dintorni, Castello di Volpaia, Radda in Chianti, Siena, Italy
1987	*Contro l'Apartheid*, Studio Massimi, Rome
1986	*L'esprit de Géométrie*, Galleria il Carpine, Rome
1985	*Desideretur*, Palazzo della Ragione, Bergamo, Italy
1981	P.S. 1 Contemporary Art Center, New York
	Gabrielle Briers, New York

Bibliography

2006

Dual Realities: The 4th Seoul International Media Art Biennale, Media City Seoul, 2006, edited by Ha Chong-Hyun, texts by Wonil Rhee, Yuko Hasegawa, Lev Manovich, Iris Mayr, Pi Li, Seoul Museum of Art, Seoul.

D'Ombra, Palazzo delle Papesse, Siena, MAN, Nuoro, text by Lea Vergine, Silvana editoriale, Cinisello Balsamo (Milan).

Annie Ratti, text by Iwona Blazwick, Alex Farquharson, Lea Vergine, Cesare Pietroiusti, Annie Ratti and Giorgio Verzotti, Charta, Milan.

2004

Gwangju Biennale, A Grain of Dust, A Drop of Water, Gwangju, texts by Yong-woo Lee, Kerry Brougher, Ko Un, Milena Kalinovska, Chika Okeke, Roberto Pinto, Won-il Rhee, Tanja Weingärtner, Yoon-gyoo Jang, Chang-hoon Shin, Gwangju Biennale Foundation, Gwangju.

Settlements, Musée d'Art Moderne, Saint-Étienne, text by Lóránd Hegyi, Fage éditions, Lyon.

Ateliers d'artistes à l'hôpital, text by Angela Vettese, Art dans la Cité, Paris.

2003

Luoghi d'affezione, paesaggio - passaggio, Hôtel de Ville, Brussels, IKOB, Eupen, Belgium, texts by Angelo Capasso, Paolo d'Andrea, Lucrezia De Domizio Durini, Micaela Giovanotti, Michel Baudson, Editions Snoeck, Ghent.

Annie Ratti, Italian Cultural Institute, London, texts by Mario Fortunato, Alex Farquharson, Lea Vergine, interview with Iwona Blazwick, Italian Cultural Institute, London.

2001

VI Biennale di scultura Cureglia SPAS-Visarte, Casa Rusca, Cureglia (Switzerland), with John Armleder, Giulio Paolini, Flavio Paolucci, Remo Salvadori, text by Angela Vettese, Charta, Milan.

Adriatico, le due sponde, 52° Premio Michetti, MuMI - Museo Michetti, Francavilla al Mare, Palazzo San Domenico (Italy), texts by Angela Vettese, Nenad Velickovic, Dobrila Denegri, Ana Devic, Meliha Husedžinović, Edi Muka, Igor Spanjol, Antongiulio Zimarino, Charta, Milan.

Rendez-vous, Ars Aevi, Galleria Novi Hram, Sarajevo.

2000

LKW-Kunst in der Stadt IV, Kunsthaus Bregenz-Bregenzer Kunstverein, (Austria), texts by Paolo Bianchi, Wolgang Fetz, Rudolf Sagmeister, Karl Markus Michel, Dietrich Diederichsen, CALC, Ross Sinclair, Verlag der Buchhandlung Walther König, Cologne.

1999

Annie Ratti, Ticosa Spazio del Moderno, Como (Italy), texts by Iwona Blazwick and Richard Noble, Giorgio Verzotti, a+mbookstore Edizioni, Milan.

From Where to Here, Art from London, Konsthalle Göteborg, Sweden, texts by Svenrobert Lundquist, Henry Meyric Hughes, Konsthalle Göteborg, Sweden.

Alle soglie del Duemilla, Arte in Italia negli anni '90, Palazzo Crepadona, Belluno-Galleria Civica, Cortina d'Ampezzo (Italy), text by Renato Barilli, Edizioni Mazzotta, Milan.

La casa, il corpo il cuore, Konstruktion der Identitäten, Museum moderner Kunst Stiftung Ludwig, Vienna, texts by Lóránd Hegyi, Henry Meyric Hughes, Hanno Millesi, Victoria Combalía, Sania Papa, Carlos Basualdo, KIM Seung-duk, Stephen Foster, Giacinto di Petrantonio, Danielle Perrier, Achim Hochdörfer, Enrico Lunghi, Maia Damianovic, Marjetica Potrč, Eugenio Cano, Museum moderner Kunst Stiftung Ludwig, Vienna.

Serendipiteit, texts by Giacinto di Pietrantonio, Gwy Mandelinck, Poëziezomers Watou, Watou (Belgium).

1998

Indoor, Serre di Rapolano, Centro Civico La Grancia (1998) / Musée d'Art Contemporain, Lyon (1999) / Stedelijk Museum voor Actuele Kunst, Ghent (2000), texts by Anne Bertrand, Giuseppe Russo and Marianna Neri, Andreas F. Lindermayr, Maria Thereza Alves, Thierry Raspail, Jan Hoet, Zerynthia and Charta, Rome / Milan.

Am horizont des Sehens, Hochschule für angwandte Kunst in Wien, Ausstellungszentrum im Heiligenkreuzerhof, Vienna, texts by Oscar Sandner, Renato Barilli, Laura Cherubini.

Dandy, Pio Monti, Rome, texts by Giorgio Franchetti, Italo Tomassoni, Angela Vettese, Pio Monti, Rome.

Riparte, Sheraton Hotel, Rome ("Progetti da camera" by Pio Monti, Rome), Pio Monti, Rome.

1997

Oscar, Galleria La Nuova Pesa, Rome, text by Stefano Chiodi, Galleria La Nuova Pesa, Rome.

Fausta, texts by Stefano Chiodi, Bruno Corà, Simonetta Lux, Italo Tomassoni, Associazione Culturale per Mari e Monti, Macerata - Galleria La Nuova Pesa, Rome.

Officina Italia, Galleria d'Arte Moderna, Bologna, texts by Renato Barilli, Dede Auregli, Alessandra Borgogelli, Fabio Cavallucci, Roberto Daolio, Silvia Grandi, Mauro Manara, Guido Molinari, Edizioni Mazzotta, Milan.
Fuori Uso '97 – Perché, interview with Francesca Pasini, Edizioni Arte Nova, Pescara (Italy).

1996
Annie Ratti, Espace d'Art Contemporain, Paris, text by Rodrigo Uribe Mallarino, Août – éditions, Paris.
XII Quadriennale, Italia 1950-1990, Ultime generazioni, Palazzo delle Esposizioni, Roma, texts by Carolyn Christov-Bakargiev, Elena Pontiggia, Giorgio Verzotti, Angela Vettese, Edizioni De Luca, Rome.
Le Mille e una Volta, Galleria d'Arte Moderna e Contemporanea, Repubblica di San Marino, texts by Giacinto di Pietrantonio, Laura Cherubini, Giancarlo Politi, Milan.

1995
FVROR POPVLI – FORVM POPVLI, text by Lina Wertmüller, Monti Associazione culturale, Rome.
Cose dell'Altro Mondo, Trevi Flash Art Museum, Trevi (Italy), text by Laura Cherubini, Giancarlo Politi Editore, Milan.
21st International Biennial of Graphic Art, Ljubljana, The International Center of Graphic Arts, Ljubljana.

1993
Arte in Classe, text by Ludovico Pratesi, Scuola Elementare Giosuè Carducci, Rome, Joyce & Co., Rome.
Rentrée, text by Renato Barilli, Mazzotta, Ancona (Italy).
Trasparenze dell'Arte sulla via della carta. Rassegna Internazionale della cultura Italiana, Centro Culturale Italiano, Beijing, text by Achille Bonito Oliva, Centro Culturale Italiano, Beijing.

1992
Artisti d'oggi a confronto, text by Achille Bonito Oliva, Galleria Sprovieri, Rome.

1991
Arie, texts by Achille Bonito Oliva, Giovanni Carandente, *Carte Segrete*, Fonti del Clitunno, Spoleto (Italy).
Praticabile – impraticabile, interview by Getulio Alviani, Studio Spaggiari, Milan.
Triennale della Piccola Scultura e del Bronzetto, texts by Pierre Réstany, Renato Barilli, Palazzo della Ragione, Padua (Italy).
Anni Novanta, Galleria d'Arte Moderna, Bologna (Italy),

texts by Renato Barilli, Jan Avgikof, José Lebrero Stals, Françoise-Claire Prodhon, Dede Auregli, Roberto Daolio, Edizioni Mondadori, Milan.

1990
IV Biennale Donna. Il gioco delle parti, texts by Ansalda Stiroli, Marisa Vescovo, Palazzo dei Diamanti, Ferrara (Italy), Gallerie Civiche d'Arte Moderna, Ferrara.
Giovani Artisti a Roma III, Venticinque giovani artisti al Palazzo delle Esposizioni, texts by Enzo Bilardello, Enrico Crispolti, Gido Strazza, Andrea Volo, Palazzo delle Esposizioni, Rome, Ed. Carte Segrete, Rome.

1989
Se una sera d'autunno…, text by Giuliano Briganti, Galleria dell'Oca, Rome.
Arca, texts by Giovanni Battista Salerno, Castello di Volpaia, Radda in Chianti, Siena (Italy).
Di terra in terra, Palazzo Borbonico, Caltagirone, Catania (Italy).
I Quaderni di San Sebastiano, text by Rosalba Pajano, Oratorio di San Sebastiano, Forlì, Comune di Forlì (Italy).

1988
4x2 Duetti d'artista, text by Achille Bonito Oliva, Studio Ghiglione, Genoa (Italy).
Il cielo e dintorni, texts by Giacinto di Pietrantonio, Loredana Parmesani, Castello di Volpaia, Radda in Chianti, Castello di Volpaia, Siena (Italy).
Il mio bosco, text by Giacinto di Pietrantonio, Studio Bocchi, Rome.

1987
Artisti italiani against Apartheid, Studio Massimi Roma, Comune di Roma, Rome.

1985
Desideretur, text by Achille Bonito Oliva, Palazzo della Ragione, Bergamo (Italy).

Design
Inmi Lee
Sorim Lee

Graphical Coordination
Gabriele Nason

Editorial Coordination
Filomena Moscatelli

Editing
Emily Ligniti

Translation
Karel Clapshaw

Copywriting and Press Office
Silvia Palombi Arte&Mostre, Milano

Web Design and On-line Promotion
Barbara Bonacina

Sales Department
Antonia De Besi

US Office
Francesca Sorace

Cover
Bird's House, 2000

Backcover
Bird's Island, 2000

Printed in Italy

Photo Credits
Claudio Abate
Marco Fedele Di Catrano
Agostino Osio
Annie Ratti

We apologize if, due to reasons wholly
beyond our control, some of the photo
sources have not been listed.

Edizioni Charta srl

via della Moscova, 27
20121 Milano
Tel. +39-026598098/026598200
Fax +39-026598577
e-mail: edcharta@tin.it

US Office
New York City, Tribeca
Tel. +1-313-406-8468
e-mail: international@chartaartbooks.it

www.chartaartbooks.it